Wilderness Manitoba

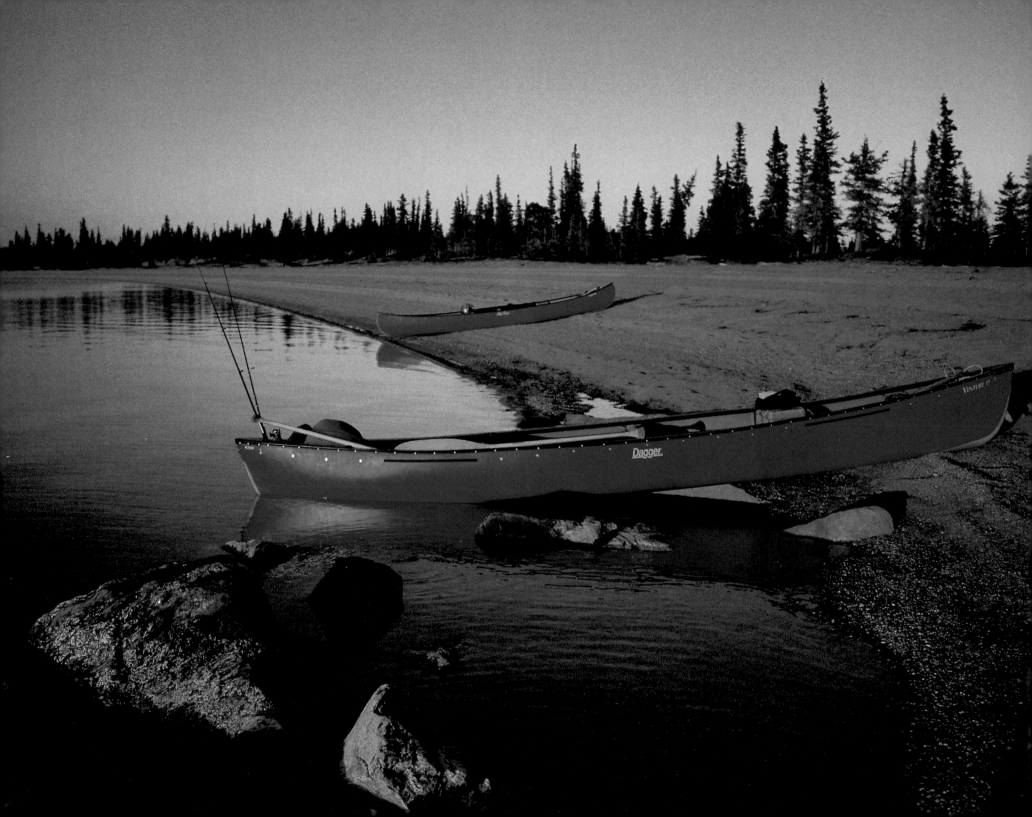

Wilderness Manitoba

LAND WHERE THE SPIRIT LIVES

Hap Wilson & Stephanie Aykroyd

The BOSTON
MILLS PRESS

Canadian Cataloguing in Publication Data

Wilson, Hap, 1951-
 Wilderness Manitoba: land where the spirit lives

ISBN 1-55046-271-7

1. Wilderness areas - Manitoba, Northern.
2. Wilderness areas - Manitoba, Northern - Pictorial works.
3. Indians of North America - Manitoba, Northern.
4. Indians of North America - Manitoba, Northen - Pictorial works.
I. Aykroyd, Stephanie, 1970– . II. Title.

FC3393.4.W54 1999 971.27′1 C999-930158-6
F1062.W54 1999

Copyright © 1999 Hap Wilson & Stephanie Aykroyd

03 02 01 00 99 1 2 3 4 5

Published in 1999 by
Boston Mills Press
132 Main Street
Erin, Ontario N0B 1T0
Tel 519-833-2407
Fax 519-833-2195
e-mail books@boston-mills.on.ca
www.boston-mills.on.ca

An affiliate of
Stoddart Publishing Co. Limited
34 Lesmill Road
Toronto, Ontario, Canada
M3B 2T6
Tel 416-445-3333
Fax 416-445-5967
e-mail gdsinc@genpub.com

Distributed in Canada by
General Distribution Services Limited
325 Humber College Boulevard
Toronto, Canada M9W 7C3
Orders 1-800-387-0141 Ontario & Quebec
Orders 1-800-387-0172 NW Ontario & Other Provinces
e-mail customer.service@ccmailgw.genpub.com
EDI Canadian Telebook S1150391

Distributed in the United States by
General Distribution Services Inc.
85 River Rock Drive, Suite 202
Buffalo, New York 14207-2170
Toll-free 1-800-805-1083
Toll-free fax 1-800-481-6207
e-mail gdsinc@genpub.com
www.genpub.com
PUBNET 6307949

For our son,
Christopher

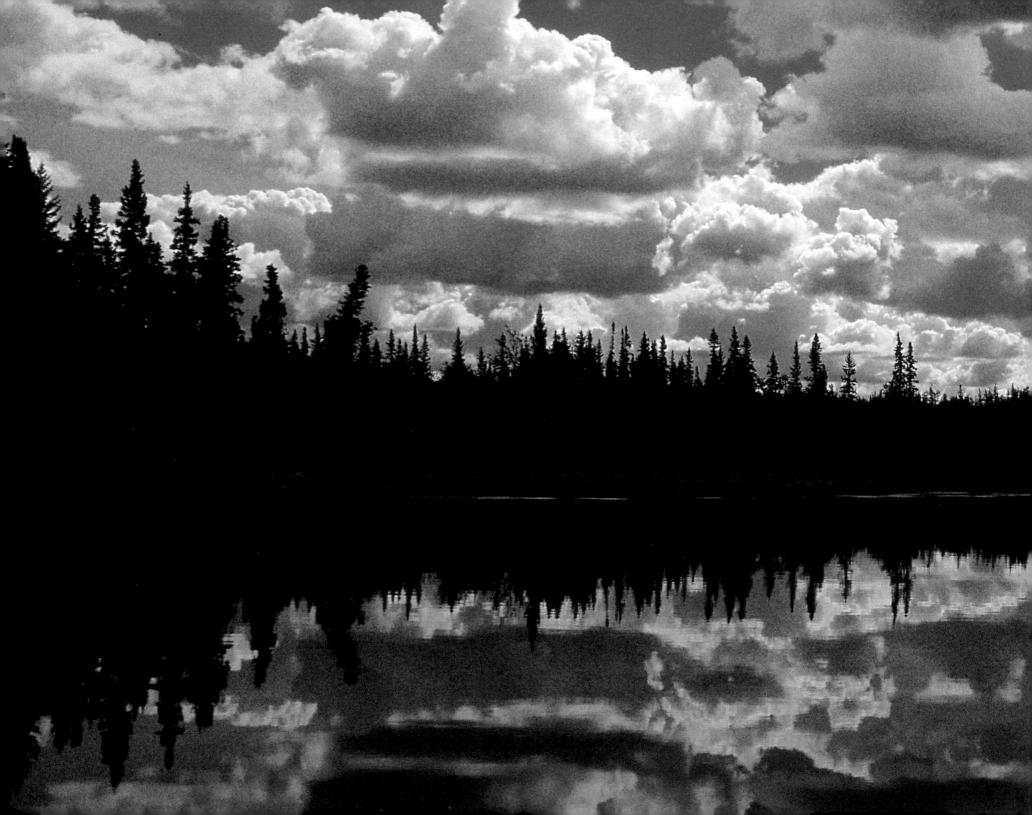

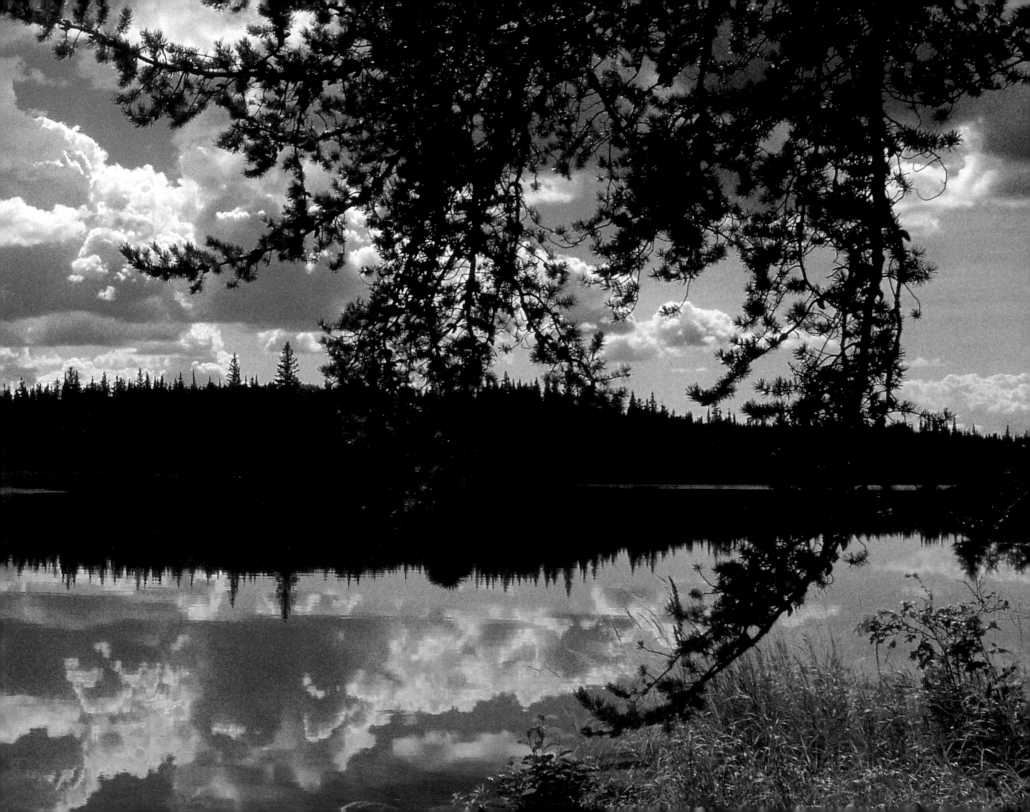

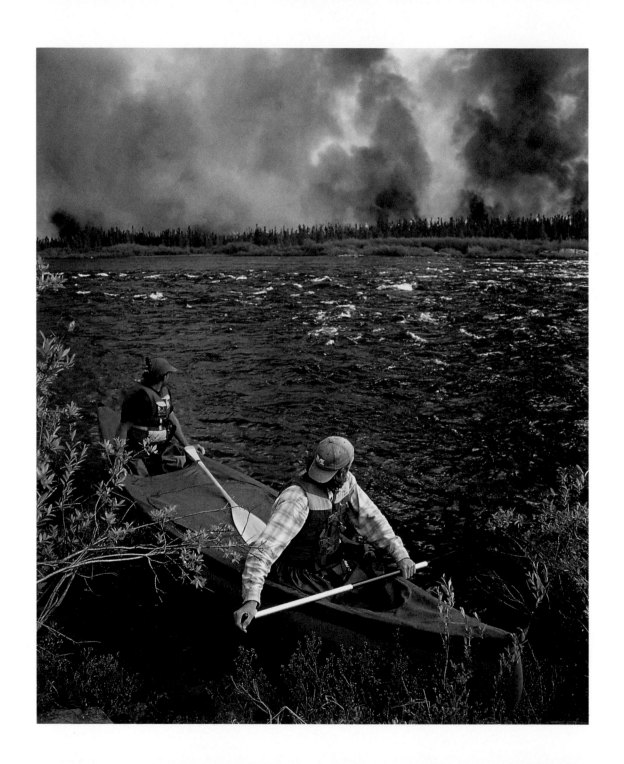

Contents

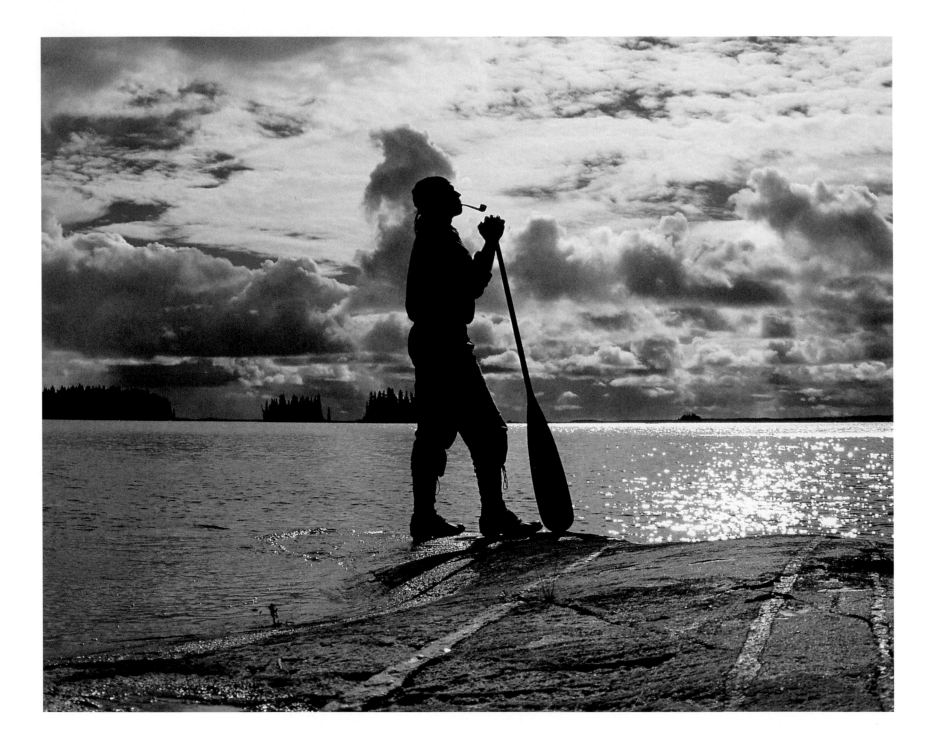

Acknowledgments

WE ARE DEEPLY INDEBTED TO THOSE INDIVIDUALS WHO HAVE STOOD BY US DURING THE five years it has taken to bring Wilderness Manitoba to life in the pages of this book. We would particularly like to thank our families for their enduring love and support, especially when our son was born midway through our work on this publication.

The assistance and encouragement of Mike Greco of the Canadian River Management Society and Jan Collins of Travel Manitoba enabled us to do the field research necessary to fully inventory the cross-section of rivers throughout the province.

We would like to thank other contributors: our dear friend and mentor Kirk Wipper, for his foreword and because he is not fully recognized for his outstanding contribution in preserving the canoe as a Canadian icon; our corporate sponsors, Novack's, C.R.C.A., M.R.C.A., Swift Canoe & Kayak, Wolverine Paddle Co., Eureka/Camp Trails, Old Town Canoe, and Dagger Canoe, for their in-kind services; *Men's Journal*, for sponsoring our first Manitoba journey; Alan and Mary Code and the Dene people, for their kind support; and our publisher, Boston Mills Press, who had faith in this project.

Thanks also to our many friends, family and clients who joined us on several of our Manitoba adventures, helping make them memorable indeed; and to our friend Elene, for once again allowing us to use her computer.

Appreciation goes to Stephen Gates of the Grey Owl Nature Trust, for supporting this project and making this book a reality. During the making of the Jake Eberts/ Richard Attenborough film about Grey Owl, we had the opportunity to work with Pierce Brosnan, in his role as Grey Owl, as personal skills trainers. Thanks to Pierce for portraying the character so brilliantly and for championing the cause of the preservation of rivers and lakes in Canada. It is our hope that this book will help convey the message so vigilantly expressed in the writings of Grey Owl, which have been an inspiration to those of us who have chosen a life on the wilderness trail.

And finally, our deepest appreciation to the Land Where the Spirit Lives, for sharing some of its secrets and capturing our hearts.

Pipe break on the Grass River.

Foreword
Wandering and Wondering

Quiet morning on the Pigeon River.

READERS WILL BE DELIGHTED AND INSPIRED BY THIS BOOK ABOUT A RELATIVELY UNKNOWN part of Canada, the Manitoba wilderness. The authors, Hap Wilson and Stephanie Aykroyd, have succeeded in portraying a marvellous landscape in a variety of memorable ways. They combine outstanding art and photography to reveal the essence of that northern environment. Although I was raised not too far from some of the wild places explored by Hap and Stephanie, I did not know much about the natural wonders of that region.

The first section of this magnificent publication addresses the spirit of place in such a way that the reader is compelled to reflect on moments and locations that have been written indelibly in our own memories as the result of our significant encounters. It is something akin to "listening points," as described by Sigurd Olson, or of inspirational episodes that we may have known in our travels into the nooks and byways of natural places. It was the canoe that enabled the authors to explore all facets of Manitoba's northland in such a sensitive way, and we the readers are the benefactors of those ventures.

In this distinguished work, the authors make reference to the ancient elements of earth, air, water and fire as the reader is invited into the ecozones that exist in the hinterlands of northern Manitoba. As we discover that territory with Hap and Stephanie, we

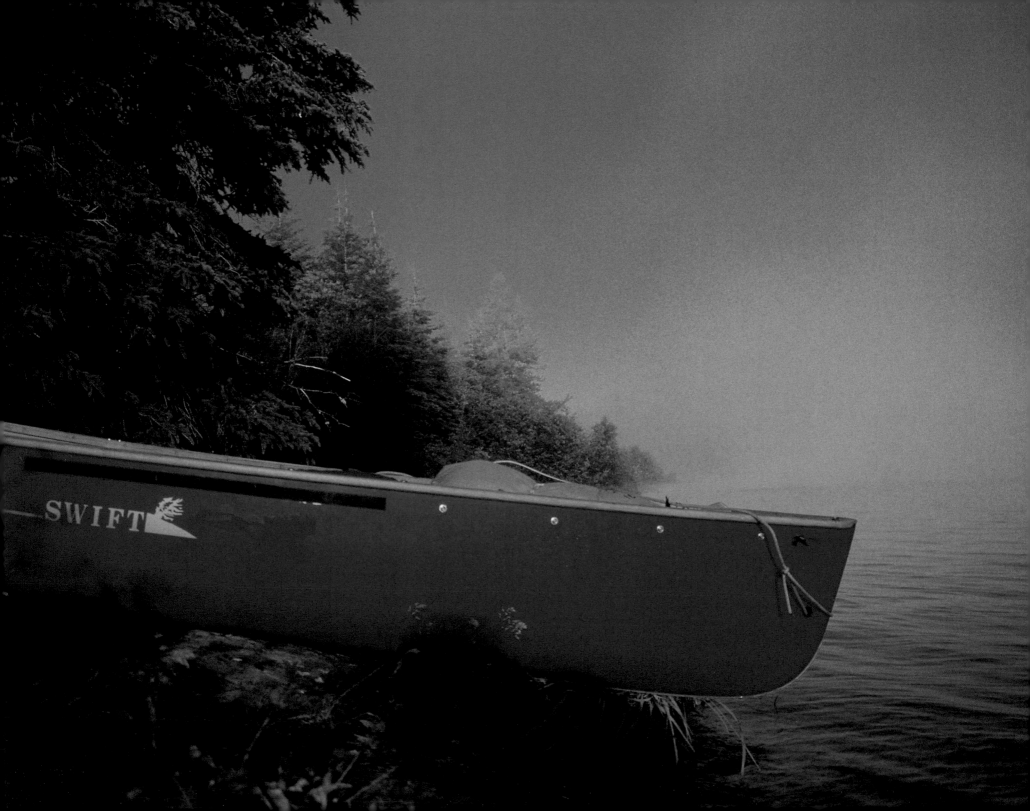

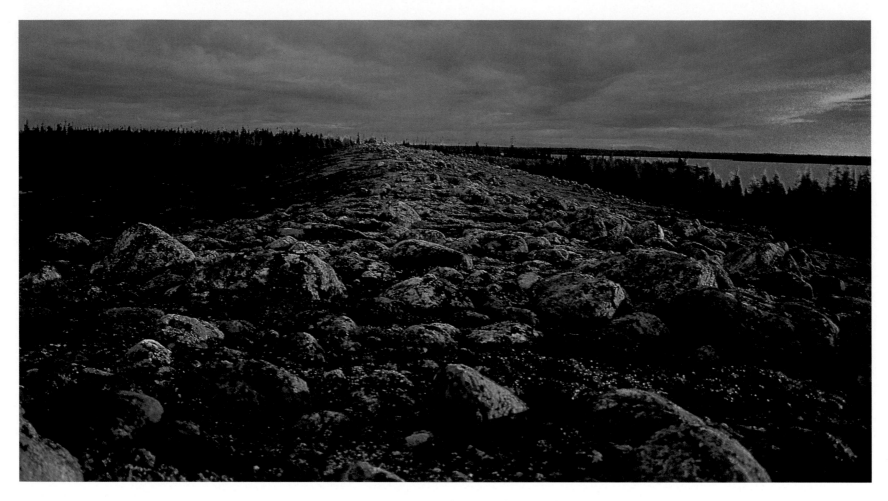

Eskers of the barrenlands. One cannot help but feel vulnerable and insignificant in such a landscape, but at the same time aroused by the narcotic of total isolation in wilderness of the purest form.

come to appreciate the grandeur and mystery of a special part of Canada, we feel the spiritual and historical essence of such varied landscape.

The journey into the Land of Little Sticks, for example, speaks of the diversity of the North. The reader should come to the conclusion that, though trees are limited in size and number, the land is not barren. In a very real sense, the term *barren* is a misnomer. Careful investigation will reveal the fact that the territory in focus is rich and vibrant with natural life, both flora and fauna. There is so much that is normally unnoticed and unseen. The authors teach us to experience the natural world by developing a sensitivity to life that we may not have previously cultivated.

The reader may very well recognize that textures, patterns, moods and colours can introduce a whole new way of experiencing life in the wilderness. We can listen to the still, small voice of quiet spaces. We may even begin to hear the spirits of the past in a waterfall — something known to the aboriginal people for centuries.

While viewing the images in this photography-and-art journal, there came into focus messages that appealed to me in a variety of ways. The reader will be reminded of the remarkable diversity of nature; of the fact that constant change is taking place; of the steady process of adaptation; and of the interdependence of all living things.

I am reminded of my growing up in the Manitoba north. As a child I often wondered about the white birch trees that seemed to stand out as guardians in the forest. They were something like white poplar but yet quite different. Time taught me about how important the white birch was to the aboriginal people. It took a long time to grasp the fact that the grain of white birch bark goes around the tree and not in a vertical manner as it does in other species. This made it suitable for canoes, baskets,

Kirk and Ann Wipper in Temagami, Ontario.

and cradles, which the Cree people made on the reserve nearby. For me, such a learning process offered deeper understanding and the joy of discovery. Such is the impact of this book that Hap and Stephanie have created for us to enjoy.

May this publication help us all to reaffirm our determination to do our share to protect the gifts of special outdoor places for future generations.

— Kirk A. W. Wipper,
Professor Emeritus, University of Toronto
founder and advisor, Canadian Canoe Museum

Introduction

This chunk of peat had broken away from the surface mat. Despite its size, it weighed only several ounces. In a place most people believe to be a barren wasteland, there exist a startling variety of unique tundra life forms.

IT IS DIFFICULT TO FATHOM HOW A FIVE-YEAR JOURNEY BY CANOE THROUGH ONE OF Canada's most multifarious and austere wilderness landscapes could have possibly taken root in a midtown New York City hotel. But the Manitoba adventure actually did begin there during the winter of 1994, as a result of pitching a story idea over the telephone to the publisher of *Men's Journal*.

A canoe-tripping associate of mine had made the initial contact with *Men's Journal* and had been fronted a ticket to come along on the expedition, but it was up to me to sell the concept of the "ultimate wilderness canoe trip" to the editors.

"Come to Manhattan," they told us, "and let's see what you've got cooking."

So we did. Luckily, my companion (who shall remain nameless) has friends who own the Roger Smith, a small, 136-room Depression-era hotel on 47th and Lexington. The proprietors, James and Sue Knowles, had spent the previous Thanksgiving holiday up at my cabin in Northern Ontario, so in return my cohort and I were offered free lodging in their penthouse suite, replete with kitchen, loft, balcony and rooftop barbecue. James is an eccentric artist who has adorned his hotel with abstract bronze sculptures, whimsical murals and ever-changing exhibits by young artists. It is this inherent

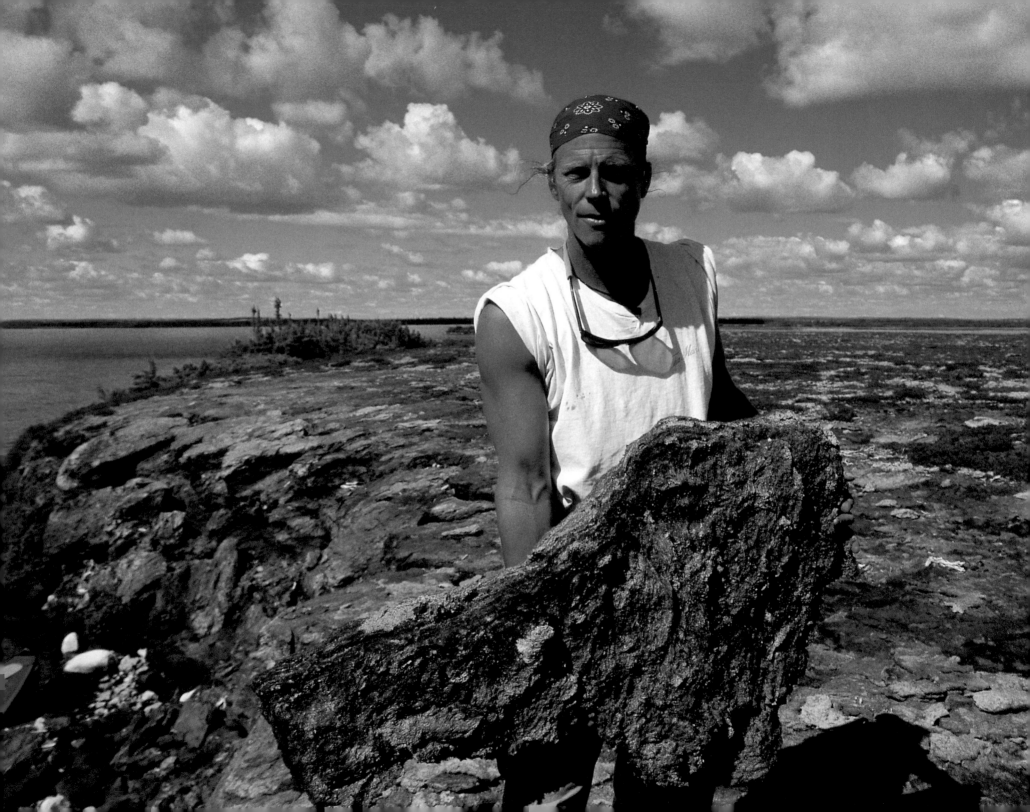

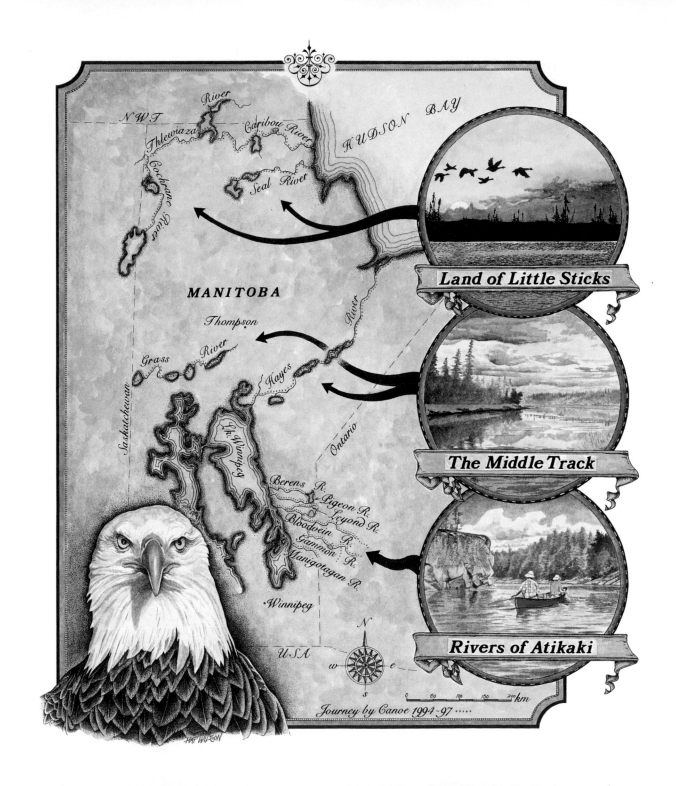

MANITOBA

Land of Little Sticks

The Middle Track

Rivers of Atikaki

Journey by Canoe 1994-97

idiosyncrasy, of hotel and owner, that has attracted a great many actors and musicians, among them singers Nanci Griffith and Lyle Lovett. The Roger Smith was once the haunt of Pete Seeger, Arlo Guthrie and Jim Croce.

We were in good company, both past and present. The Knowleses' eclectic interests had helped them establish a niche in the New York hostelry trade but had also led them to paddle and spend time in the Canadian wilds. We felt at home here, in a world far removed from the call of the loon and frenzied bite of mosquito. As an artist and photographer, I appreciated the ambience and winsome quality of the Roger Smith. "I like to call it a hotel with an art bias," Knowles asserted. "More than anything, I want this hotel to be a place where good ideas can occur." Well, I was working on a good idea, and there was good energy here. If my canoe expedition story was going to fly, it would be here.

I had invited the *Men's Journal* editors to the hotel for an evening slide show of some of my past adventures in Quebec and Ontario, places where I had guided trips over the last twenty-five years. Molly Barnes, the hotel's curator, prepared the eighteenth-floor reception room for the event. The decor was contemporary American, perfect for one of the hotel's other legendary guests, R. Buckminster Fuller, who was given this room (without a bed) in the 1930s when he was broke and destitute. The room's cove ceiling, accented with tiny triangle-patterned bas-relief, is said to have inspired Fuller's invention of the geodesic dome.

Oddly enough, I found myself in Fuller's shoes — looking for inspiration, furnished with a free room and complimentary breakfast, and with only about twenty dollars left in my wallet. I needed the inspirational magic of the room to help me convince

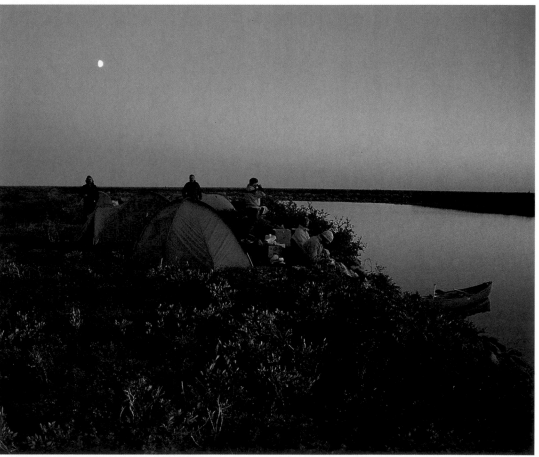

Nowhere else did we feel so unprotected as we did pitching our tents on the tundra plain near Hudson Bay, open to the elements and to night visits by roaming polar bears. But with the rising moon and the show of stars and northern lights, we easily forgot about the worrisome forces of Nature.

Men's Journal to bankroll the Seal River canoe expedition through the barrenlands of northern Manitoba.

Why I had chosen that particular river was one of those karmic circumstances that one does not question. If it wasn't fate then it was pure gut-feeling. I had several rivers to choose from, such as the Nahanni, Canada's hallmark heritage river, but you almost have to take a number to find a slot on the roster of paddlers now running that famous river. If I were to guide a team from such a prestigious New York magazine, I knew that the location would have to have the correct formula for adventure: isolation, cultural history and unparalleled aesthetics — not to mention hair-raising whitewater rapids, the element of "extreme" danger, intrigue, and at least one or two token animals ranking above humans on the food chain.

The Seal River is one of those aloof water routes that is either too difficult for most paddlers to run safely or too expensive to fly to and from without having to hock the family heirlooms. *Sheth-tie-eye-desay,* meaning "river that flows out of," is the Chipewyan or Sayisi Dene name for the Seal. It attained heritage status in 1992. It gained this designation because of its seven thousand years of prehistory, its dynamic geologic features, and its recreational possibilities. For me, it was a river 300 kilometres north of the nearest settlement, and it flowed into unpredictable Hudson Bay, whose coastline is revered as one of the world's most inhospitable environments. (Not a lot different from New York City.) The Seal was a perfect choice. I just had to convince *Men's Journal.*

That evening, guests — mostly hotel patrons and staff — filed into the elegant reception room. The lights were dimmed and the slide show was executed flawlessly. But the *Men's Journal* editors showed up *after* the presentation, just as people were leaving. I confronted features editor Peter Griffen and fully expected a tough New York rejection speech. Instead I received a firm handshake and a go-ahead for the expedition in northern Manitoba.

"We were already sold on the story," said Griffen. "We didn't need to see anything else."

One of Manitoba's largest and most destructive boreal wildfires became the hallmark feature of our premier wilderness adventure along the Seal River. It burned night and day and followed us for over 120 kilometres downriver, so intense at times that we often wrapped wet bandanas around our faces so we could breathe the acrid smoke-filled air.

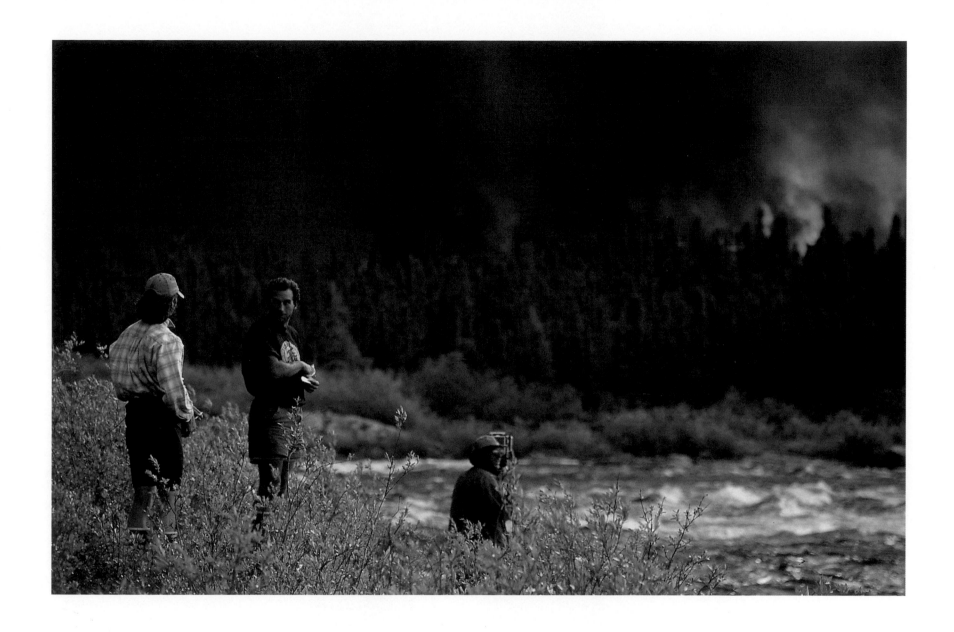

Primary colours. Water lilies on the Thlewiaza.

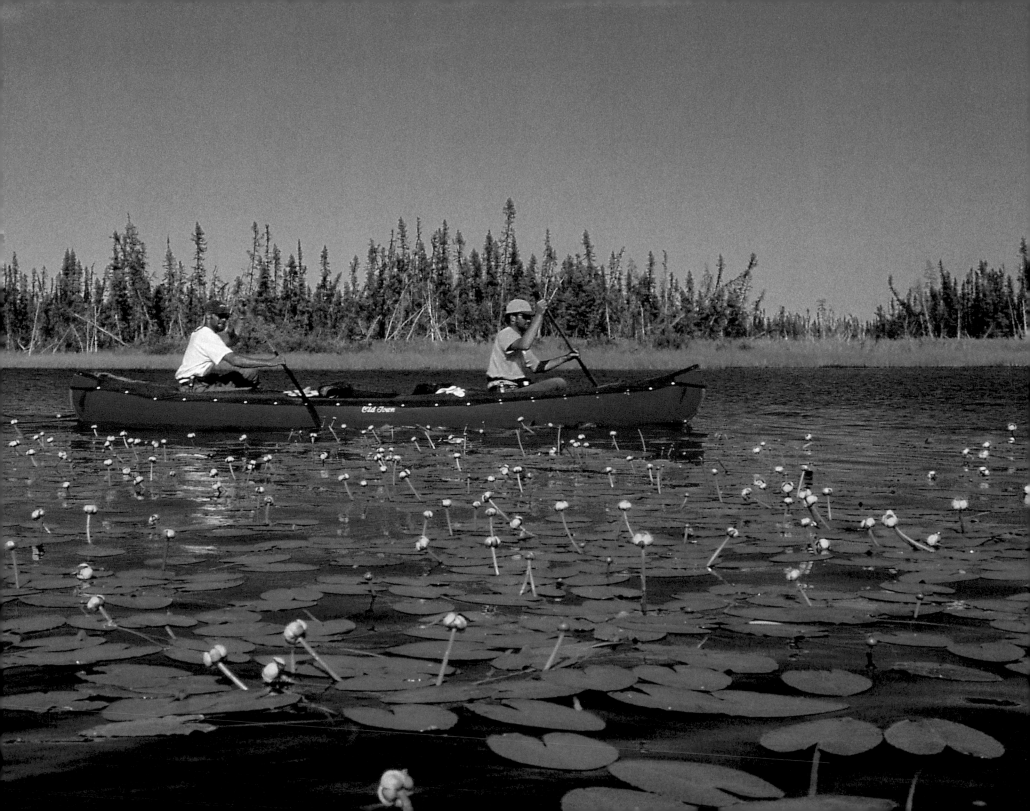

Perhaps we have good travelling karma, or maybe it had something to do with our ceremony with the Dene medicine healers at Lac Brochet. Either way, we were blessed by calm weather on almost all of the large lake crossings. The sun was intense as we paddled the last section of Nueltin Lake on our way to the Caribou River.

The jumpstart that I received in New York for the Seal River trip spawned a much more ambitious project, a canoeing guidebook for the provincial tourism ministry. This entailed the mapping and researching of sixteen more wilderness-class rivers and the production of a field-friendly manual much like the ones I had produced for Temagami, the Ottawa Valley and the Missinaibi Heritage River in Ontario. Mike Greco of the Canadian Heritage River Board and Jan Collins of Travel Manitoba were the driving forces behind the project, from a political perspective, and encouraged us through the next five years of blood, sweat and paddling blisters. There certainly were hard times, in the field and at home, but there were no bad times. The opportunity to explore such a grand and pristine wilderness assuaged any trepidation about finances or hardships endured while in the field.

The selection of Manitoba rivers was not a disconcerting task. It was a simple matter

of excluding those rivers whose nature and spirit had either been muzzled for hydro-power, shorn of timber, or intruded upon by that ever-prolific webwork of forest access roads. The inventory of such unfortunate Canadian rivers is increasing steadily and irrevocably. The diminishing catalogue of unsullied waterways is thus easily defined.

Within Manitoba there are five distinct ecozones. In ecological terms, this makes Canada's heartland province the most diverse landscape in North America. The wooded grasslands or prairies of the south, resplendent with their sweeping vistas, broken only by lofty grain elevators, occupy only one-twelfth of the total land mass of 650,000 square kilometres. The definitive personality of Manitoba has been typecast as one of endless wheat fields and roaming buffalo herds. What people fail to comprehend is the vastness of the remaining wilderness, five times the size of England yet with only one-fiftieth the population — and the majority of Manitobans live within the greater Winnipeg area.

Ecological disparity continues north and east, blending with the mixed meadows of the lower Lake Winnipeg and Lake Manitoba regions before blossoming into that great medley of rock, jackpine and spruce that typifies the rugged carapace commonly known as the Precambrian Shield, the oldest rock on this planet. From here the hinterland adopts a rather complacent and noble attitude. Endless legions of spruce make their way to Hudson Bay. Finally, there are the great barrenlands and Arctic tundra, harsh yet alluring with their if-you-dare disposition, chromatic sunsets, ranging caribou herds, and, along the shores of Hudson Bay, the world's largest concentration of Beluga whales.

Wilderness Manitoba had captured my heart and provoked my soul with its contrasting landscapes and rich native culture, unmatched anywhere else in this country. Not only was my own insatiable appetite for adventure soon to be fulfilled, but so was the need to retain and capture all those wonderful experiences either on film or in the sketchbook. There was also the environmental angle. The Manitoba wilderness is inspiring. It is refreshingly pristine and untrammelled. It is also endangered.

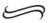

Wet boot offerings to the sun at
Whitemud Falls on the Hayes River.

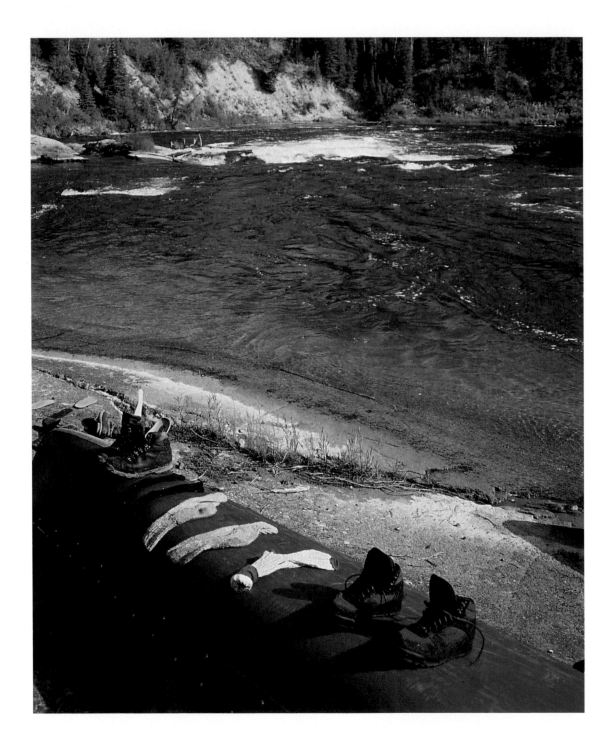

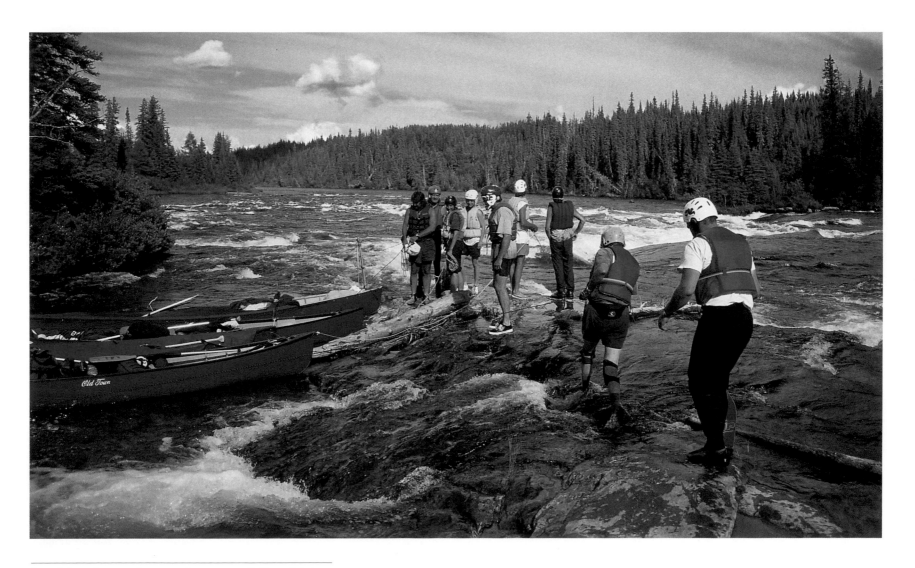

Impulsive photography sometimes pays off. The trick is to
take the shot without people knowing you are taking it.
Lining rapids on the Hayes River.

The Grass River is at a high enough latitude to experience morning frost even in mid-August.

My wife Stephanie joined the Manitoba journey in 1996. We first met while paddling the Hayes River together as far as Hudson Bay. She is an accomplished artist with a flair for detail that often eludes me. She applies her uncanny sense of balance and composition to both her paintings and her photography. Stephanie's devotion and tireless energy, both on the trail and in the studio, brought new life to the Manitoba book projects.

Even though the foremost reason for travelling the wild corridors of the province was to classify rivers for a travel guidebook, it became apparent that this fragile environment and river resource also needed more protection, from commercial development and from humankind in general. The paradox of nature-writing resides in the tormenting question of whether or not to reveal secret and often sacred places. It weighs heavy upon the shoulders of responsible nature writers who, if not careful, may fall upon their own swords. But how can we hope to save these special places if people don't even know they exist?

Here is a wilderness like no other, a land almost forgotten even by its First People, a paradise ripe for harvest by the industrial hand of man. This wilderness has already suffered indignities: the Nelson and Churchill rivers have been dammed to harness their energy; mining and logging interests have pushed deeper and deeper into the great life-sustaining boreal forests. We travelled nearly 5,000 kilometres by canoe over a four-year period and met less than twenty other paddlers. This is some of the finest wilderness in North America, and we can only hope that the wise use of and respect for nature prevails.

Our biggest coup was in gaining the confidence of the Manitoba Tourism Ministry, an arm of the enlightened bureaucracy who realized that tourism was more than just

Travelling unprepared in the far north is foolhardy. Weather changes almost by the hour; you're either sweltering or fending off the icy arctic winds.

five-star fishing resorts and bus tours. The sale of the wilderness persona, as a commodity, is more valuable today because of its paucity. Eco-tourism, or self-propelled adventure travel, has been recognized by more responsible public administrations, in part due to the verification of this industry's economic contributons. In some instances, eco-travel needs have even been factored into management policies for public lands. There is still a long way to go. Our personal goal, as environmentalists, was to somehow bring to light the preciousness of the Manitoba wilderness, not as measured in consumer or tourist dollars, but as a land that exemplifies the spiritual heart of Canada.

The loss of wilderness each year — provincially, nationally and globally — is staggering. Faustian politics often side-step the issue of wilderness protection unless there is some kind of public outcry. Stephanie and I hope that by expressing the intrinsic beauty of the Manitoba wilderness in this book, we will raise public awareness as to the need for better protection and corridor management of the province's 100,000 lakes and rivers.

It is such a privilege to be able to share our experiences through our photography and artwork, and we hope that from this book you will better understand the sense of quiet drama that takes place here, in this great Manitoba wilderness. This is a pictorial journal, a photo-diary of our travels through a land shaped by time but almost forgotten, a land whose history has barely been recorded. We hope that the diverse imagery of this landscape will tantalize your imagination as you turn the pages and join us in the Land Where the Spirit Lives.

— Hap Wilson

About the Photography

AT FIRST, PHOTOGRAPHING THE MANITOBA WILDERNESS WAS INCIDENTAL, SINCE THE main purpose for being there was primarily to offer guide services. *Men's Journal*, much to my chagrin, sent both a writer and a photographer along on the Seal River expedition in 1994. I had at least wanted to take credit for one or the other professional duties rather than be known as the guy who cut firewood and brewed camp coffee. I decided to chart out the river for use as a travel guide and update topographical and government maps. Much of my time was devoted to writing in my own journal, taking field notes and sketching, not to mention trying to get neophytes down a wild river through one of Manitoba's worst boreal forest fires. After scouting rapids, daily meanderings, and attending to camp chores, there was little time left for creativity. I persevered. As it turned out, the photo opportunities were just too incredible to let someone else take all the credit and glory. My only regret was that I had not taken enough film with me.

After the Seal River trip I was more prepared photographically, and eventually, with Stephanie's second camera and keen eye, we were able to concentrate more on composing and exploring different possibilities. Wilderness is seldom static. We discovered that some of the best pictures were spontaneous and unplanned. Timing was critical. The best hues and contrasts during the magic hour often last but a few brief moments, barely enough time to pull cameras from their cases. Circumstance often lends itself to opportune photo play, such as snapping shots in between draws and pries while descending a wily class IV rapid, knowing well that our insurance premium has lapsed. We tried to seize every opportunity in order to fully inventory our Manitoba experiences.

Neither of us believes in pursuing wildlife just to get a good photograph. We prefer to record our adventures as they unfold. There are many photographers devoted to this field of work, and a profusion of wildlife-related photography books, but there is little record of the type of wilderness that few people will ever see.

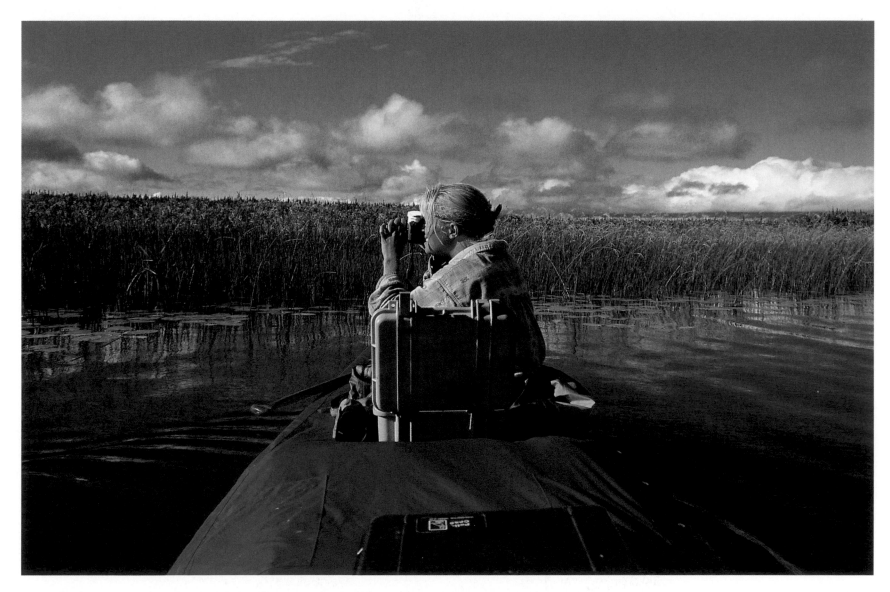

All of the photographs in this book were taken with a 35mm SLR Canon EOS A2E and Elan IIE, both with eye-control imaging. The primary lenses used were 28-80mm and 75-300mm ultrasonic zoom. The only filter employed was a 58mm glare polarizer. We preferred not to use trick photography, multiple exposures, or colour-enhancing filters. What you see in this book is exactly how we ourselves experienced it.

Spirit of Place

Daybreak on the Pigeon River.

MANITOBA IS THE GEOGRAPHIC HEART OF CANADA, AND OF NORTH AMERICA. THE ancestors of Manitoba's First People entered the parkland areas of the southwest almost 12,000 years ago. They followed the retreating glaciers of the last ice age and the receding meltwaters of Lake Agassiz north and east to the shores of Hudson Bay. Each aboriginal group adapted to its specific environment. When Europeans arrived in the seventeenth century, they encountered four distinct Native nations, each residing in a different physiographic region of the province: the Chipewyan or Sayisi Dene on the northern tundra and Hudson Bay coast; the Swampy, Bush and Rock Cree on the great boreal range north of Lake Winnipeg; the Anishnabe or Saulteaux Ojibwe in the Precambrian Shield woodlands; and the Assiniboine and Monsoni in the parklands and prairie region.

Oral histories of the First Nations, supported by archaeological findings that include pictographs, artifacts, dolmen stones and waymarkers, have allowed us to better interpret and understand the traditional cultures. Manitoba's First People were deeply spiritual, with religious convictions and sacred ceremonies reflecting their strong association to the Earth Mother and her bounty. Their connection to the land and their belief in harmony with Nature emphasized a reciprocal bond between all life-forms.

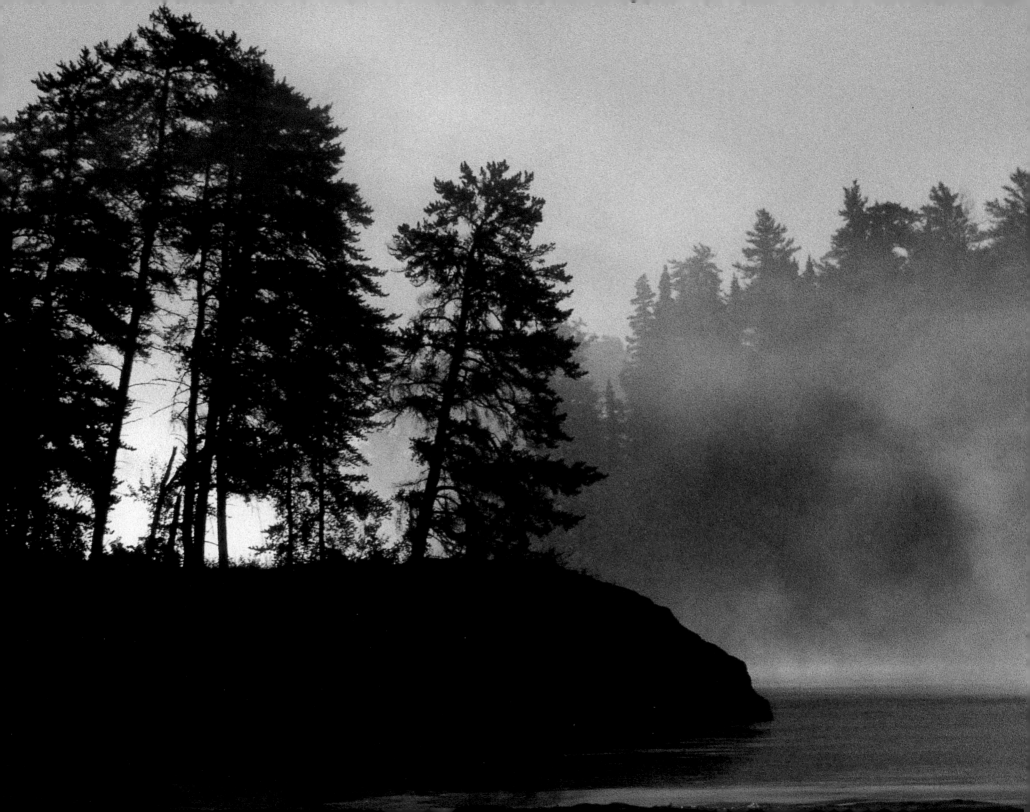

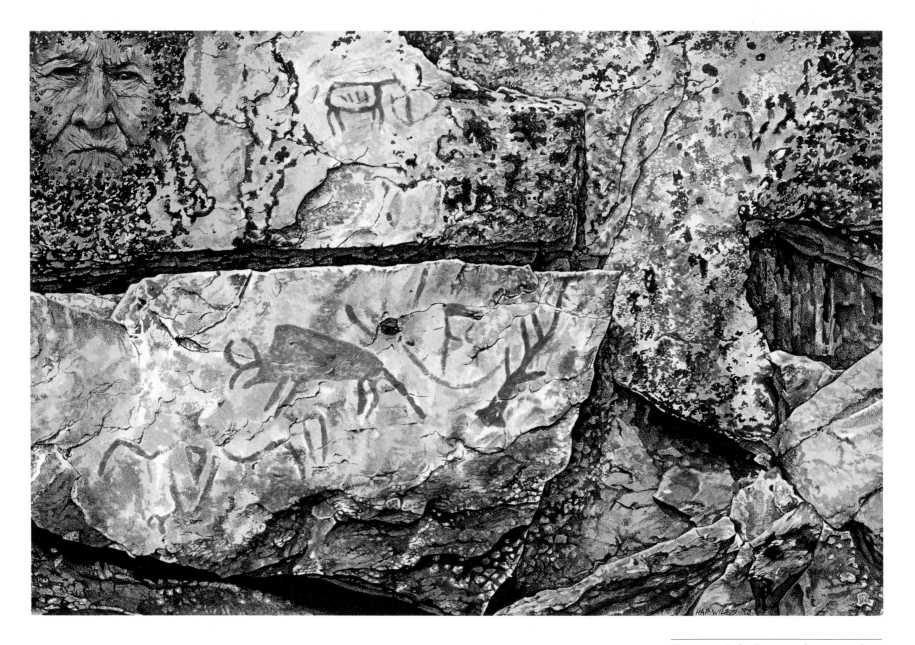

Tramping Lake Pictographs, watercolour
and stippled ink, Hap Wilson.

The name Manitoba is derived from the Cree and Ojibwe word *manitou* (spirit) and *bau* or *baw* (strait or narrows of the spirit). *Manitou-bau* means "land where the spirit lives." It refers to the impetuous character of the Lake Winnipeg narrows, where strong winds from the north or south send waves crashing against the limestone shingles of the weatherworn coast. The eerie, mystical sound of wind and wave was thought to be the voice of the Gitche Manitou (Great Spirit).

To better understand the Spirit of Place from the perspective of the First Peoples, one first must shed the colonial view of wilderness as something to be feared and conquered. Native prophet Luther Standing Bear stated in 1933: "Only to the white-man was nature a 'wilderness' and only to him was the land 'infested' with 'wild' animals and 'savage' people. To us, it was tame. Earth was bountiful and we were surrounded with the blessings of the Great Mystery."

How we, as a developed, enlightened, and overly utilitarian society, perceive wilderness is dependent upon our personal lifestyles, our knowledge of the way Nature works, our experiences cultivated in the outdoors, and our political and religious beliefs. Non-Native Americans of European descent tend to view the ways of the universe in linear terms: a forest thrives, trees mature, and if they aren't harvested for fibre, a forest serves no purpose. The Aboriginal perspective embraces all life as being interconnected within the Medicine Wheel, or Circle of Life, where there is no beginning or end, just rebirth and renewal: a forest dies and from it springs new life. Aldo Leopold perhaps best explained our dis-communion with the earth: "We abuse land because we regard it as a commodity belonging to us. When we see land as a community to which we belong, we may begin to use it with love and respect."

First Nations people, while they have adopted at least in part the ways of modern society, still tend to view wilderness as a spiritual reference to the Circle of Life. For us to have insight into the ancient Spirit of Place possessed by the Manitoba wilderness,

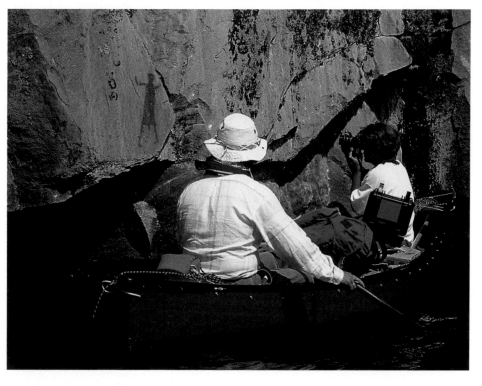

Bloodvein River pictographs.

let us view it from the pathway of the sacred Medicine Wheel, with its four cardinal directions. Each direction represents one of the four basic elements: wind (north), fire (east), water (south), and earth (west). It is interesting to draw Manitoba within the Circle and to note the relationship that each element has with the character traits of each physiographic region.

There are many spiritual connotations at work here: Manitoba, as the central geographic axis within the great land mass and centrepoint within the four regions of Canada (the western cordillera, the northern territories, the central plains and the eastern provinces). Provincially, the element water in the south could be represented by the powerful energy of Lake Winnipeg; the earth in the west, the fertile plains; the wind in the north is an ever-present feature presiding over the vast barrenlands; and the fire in the east represents the cyclical nature of rebirth after forest fires (in a region where fire is required to maintain ecological integrity and continuity).

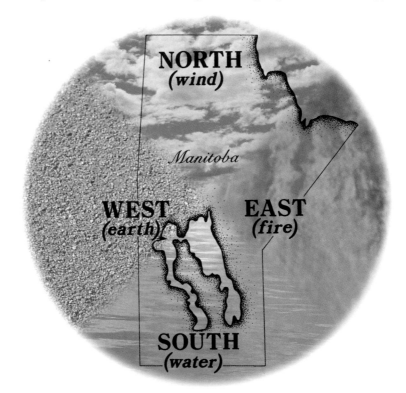

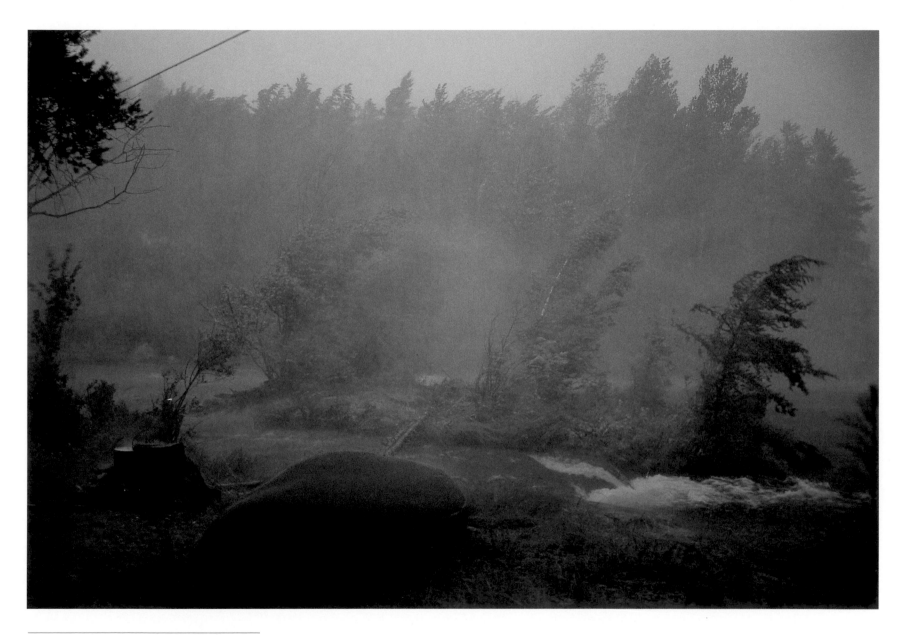

The power of the four elements unleashed in
a summer storm along the Bloodvein River.

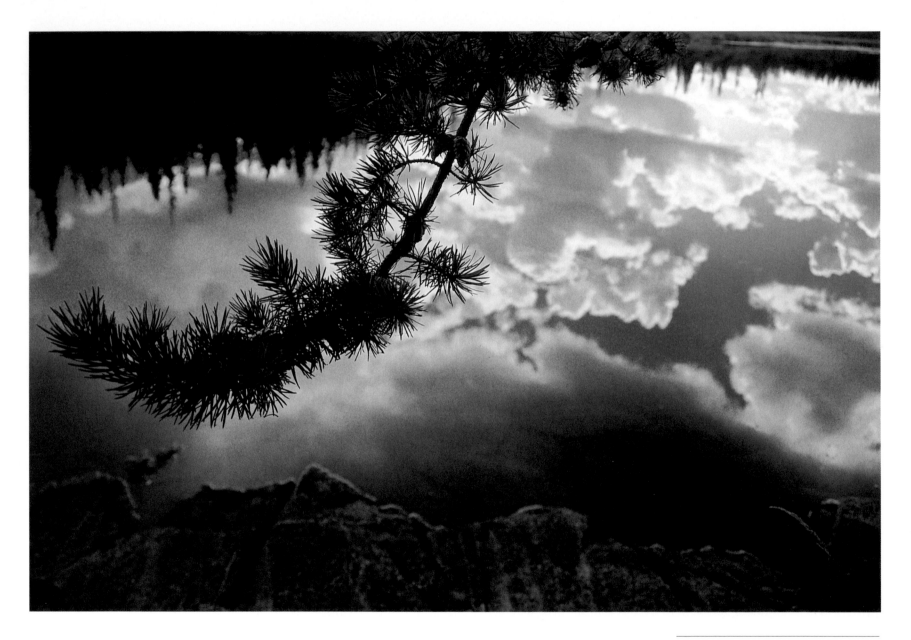

Sometimes it's hard to tell the mirrored
image from the real thing.

The images in this chapter celebrate the cycle of life as represented by the four basic elements — water, earth, wind and fire. These components of the environmental process have, through time, moulded the physical character of the Manitoba wilderness. Each element, acting independently or in combination with others, has etched its primal artistry over the skin of Mother Earth. Three billion years of geologic time have laid a foundation for forest and stream, and for those who dwell among the shadows and roam the tundra. It is a unique landscape in Canada, where one can find prickly pear cactus on a portage along a southern river, or a vast subarctic plain where life depends upon mosses and lichens that thrive precariously atop a permanently frozen world.

Water conducts, nourishes, shapes and connects. It portrays the fluid motion of life, never stationary, moving through chasms and channels, tugged by gravity to some greater body of water, to be once again raised by the energy of the sun and transported by wind and cloud to fall upon the land and to start the journey over. Water absorbs and reflects light, creates mirages and mirror images. It fools us sometimes with its gentle, passive nature. It allows us to take our canoe across great distances where shorelines are barely discernible, but once aroused by a modest current of air, the character of water transforms and pulses with an unpredictability that sends us scurrying for the shelter of the nearest cove. For a photographer, water is the most versatile element to work with. Harsh accents can be softened to create a particular mood, or the angle of light changed, or reflective qualities introduced to give a new character to the moment. A cleansing rain may beautify the strata of otherwise pale granite. Water droplets suspended in a spider's web may reveal a jewelled latticework when touched by the morning sun.

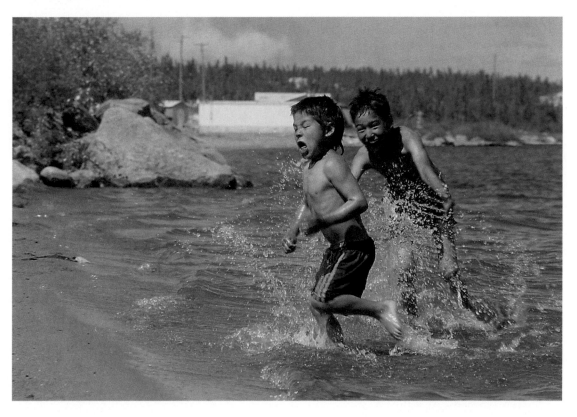

Sayisi Dene children frolic at a beach in front of the village of Tadoule while raging forest fires burn only two kilometres away.

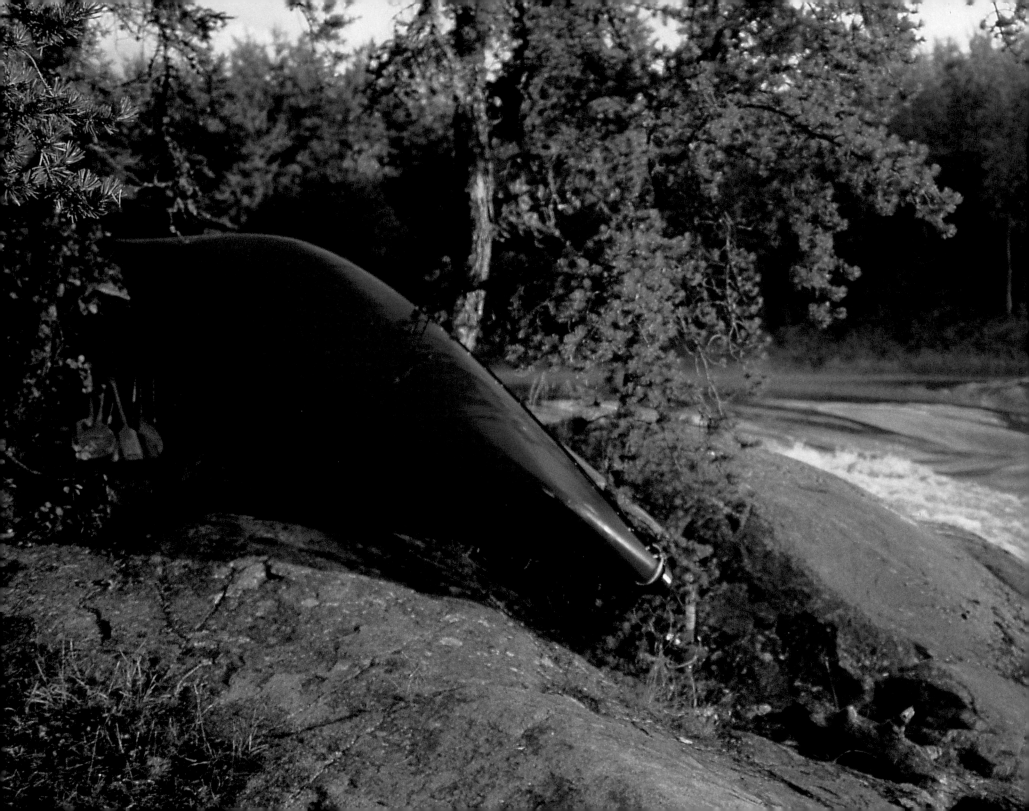

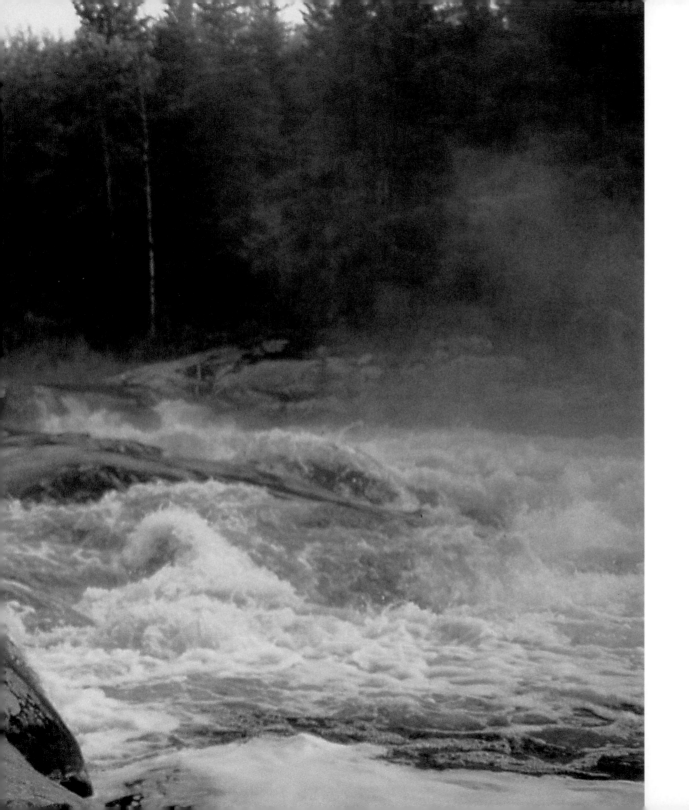

The often turbulent and demonstrative nature of water is represented by the many falls and rapids that give the Bloodvein River a bold reputation as a river with character.

Deep in the barrenlands, this lichen-crusted monolith stood guard to one of the most beautiful sand beaches on Nueltin Lake. Glacial erratics like these are tossed about in no particular pattern, exemplifying the whimsical nature of Nature. Great ice sheets carried these specks of dust for uncountable distances before depositing them upon a scoured earth. I liked the aloneness of this boulder, its bold fissures and volcanic folds, and the fact that no matter where you stood on the beach, the rock was always a focal point.

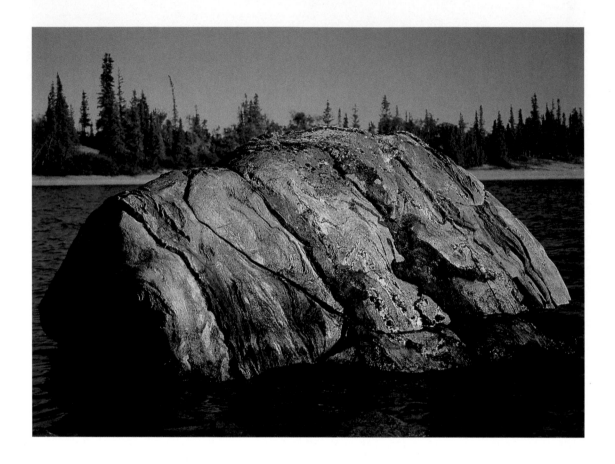

On our third day out from the Dene village of Tadoule on the Seal River, the cold drizzle crystallized against the exposed flesh of our faces as we paddled against a relentless east wind. We took shelter in a natural harbour and set up camp at the same site used by Samuel Hearne in 1770. The sun finally broke through the stronghold of clouds, and its final beams cast an almost surreal light over the landscape. It lasted for less than two minutes. Final light is like that — ephemeral and taunting.

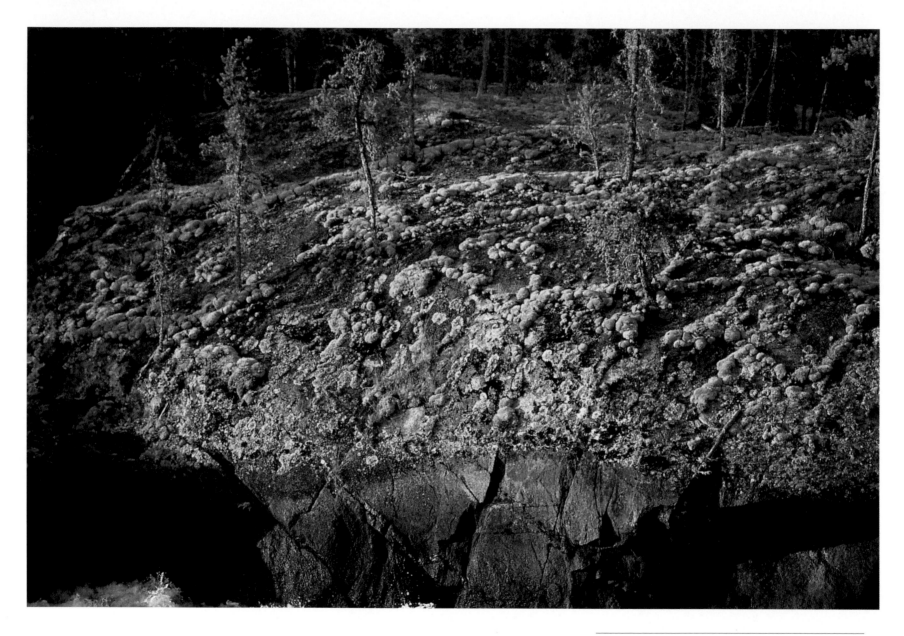

Lichen mosaic on granite along the Gammon River.

Earth, steadfast and stoic, represents stability and endurance. It is the shape and contours of the earth that give water its personality — recumbent when gravity no longer matters, cascading from high cataracts, or spilling in torrents down sinewy river courses.

The earth is a stage upon which all other elements perform in the Cycle of Life. Manitoba's drama of place occurs in its granite outcrops and limestone terraces, the erratics and glacial debris scattered over the tundra plain like strange pieces in a terrestrial board game, once moved by great ice sheets several kilometres high. This landscape is adorned with a myriad of arboreal life-forms, unique plants and uncountable lush mosses and lichens. The artist or photographer with a keen eye for detail will see beyond the sometimes overwhelming pageantry of earth forms and glean the less obtrusive artistic representations — bark textures, veins of quartz intruding into slabs of grey and pink granite, the mosaic patterns of lichen and grass clinging to rock fissures and crevices, the chaotic arrangement of stones along a gravel beach.

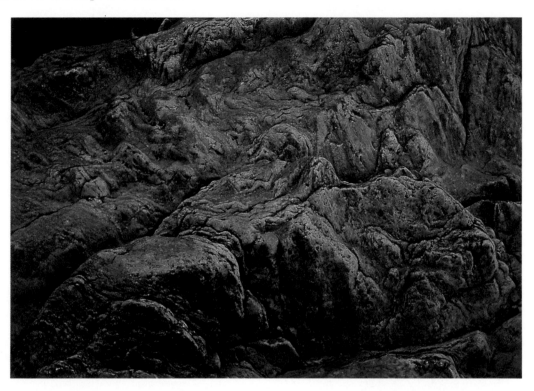

Most aboriginal people believe that even inanimate objects possess a soul and a spirit. Life flows through this stone face in gentle waves, giving its spirit a liquid energy.

Wind denotes the flexibility of the natural world. It can be as subtle as a baby's breath or as tempestuous as a cyclone. It can control the nature of waves on the surface of a lake or gather and disperse the clouds in the sky. Wind can caress the forest and gently rustle the leaves, or it can snap huge pines as easily as if they were matchsticks. Wind changes the chemistry of snow; it drives cold rain into our faces as we paddle; it cools us on hot days; it keeps the flies to tolerable levels in early summer; and it can make us miserable on cold days when we try in vain to stay warm. Wind tests our flexibility and adaptability to changing natural conditions. For the artist, wind shapes trees to its prevailing breezes, it adds vitality to a water surface, it carries an ever-changing procession of clouds across the skyscape. Wind dictates the type of climate, from warm prairie zephyrs to bone-chilling blasts descending from Hudson Bay and the high arctic.

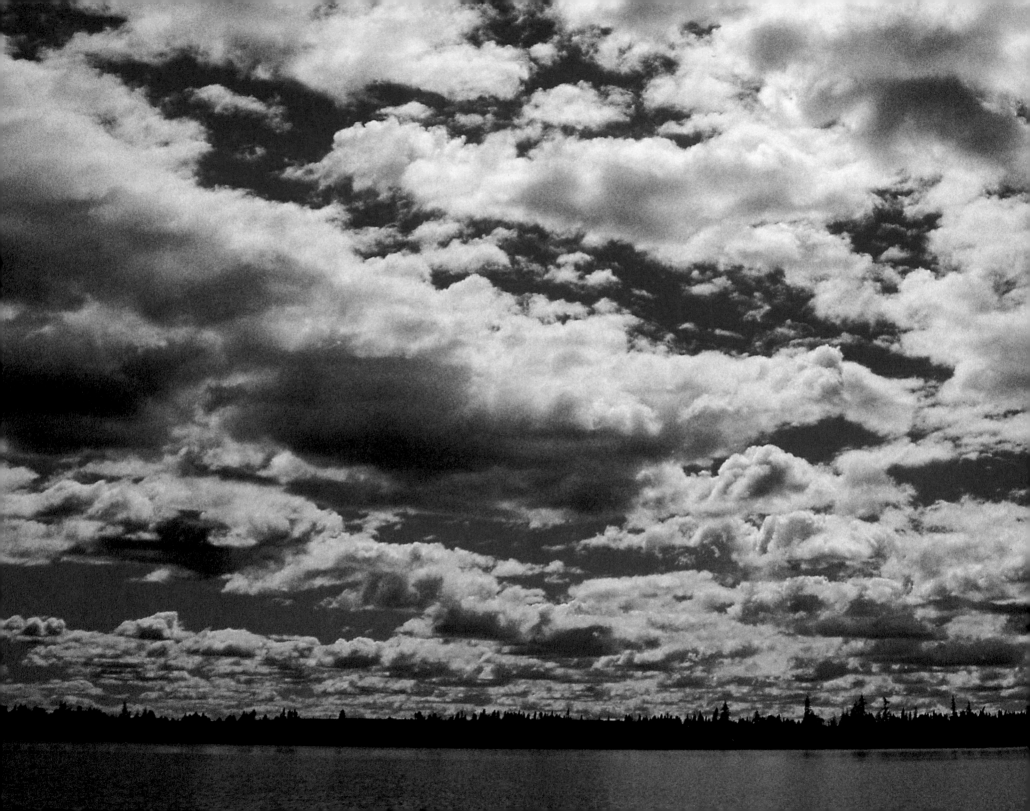

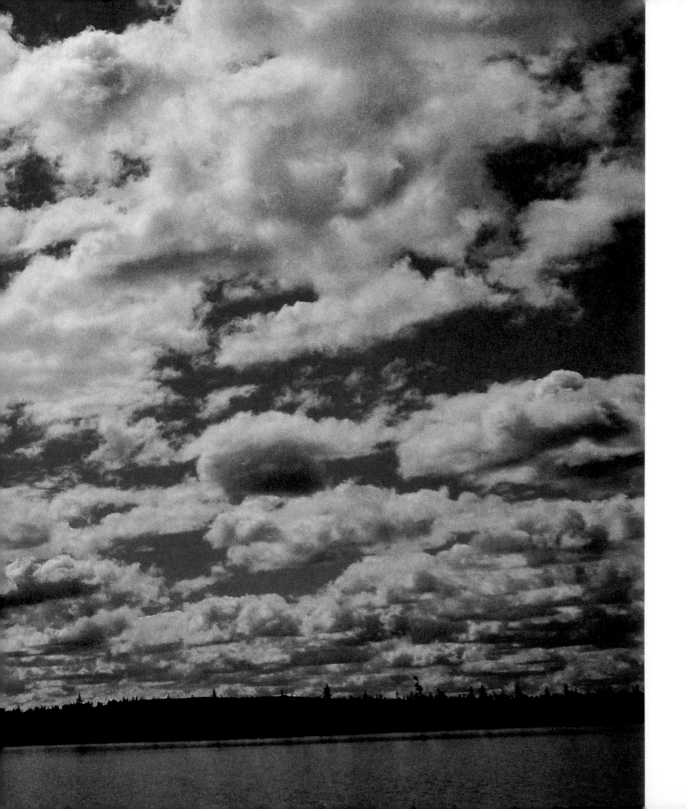

Manitoba barrenlands, true big sky country. A procession of clouds drift lazily over the boreal tree line, prompted by an omnipresent wind.

To experience first-hand the explosive power and consuming energy of a wildfire is a frightening experience: there are no boundaries set by the forces of Nature, no compromises, and no discrimination.

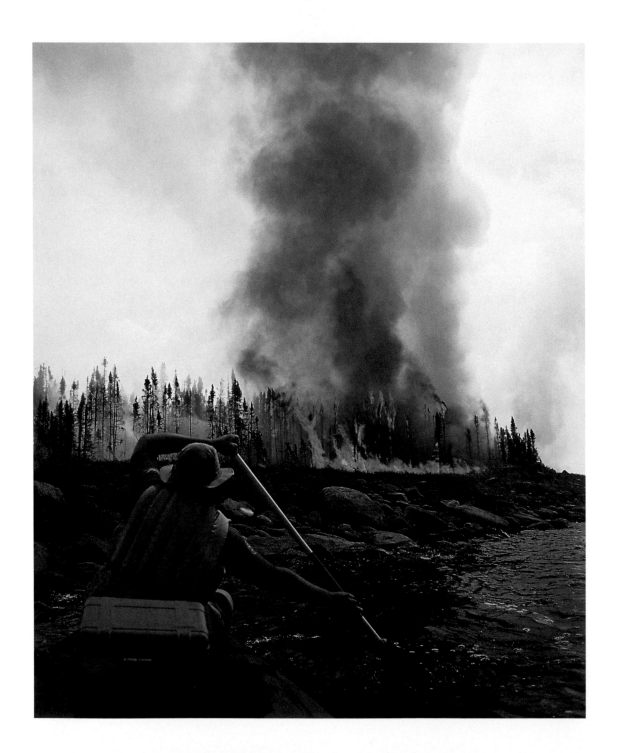

Fire teaches us expansion and illumination of the spirit, rejuvenation of the physical properties of existence, and provides the primal gifts of light and warmth. Fire is dependent upon the earth and wind for its energy, while water can extinguish or displace its vitality. At a campsite, we orbit around the evening fire like planets around the sun and are mesmerized by its hypnotic qualities. Fire destroys, but it also resurrects and revitalizes a forest as part of the ongoing Cycle of Life. Within its consuming and terrible force there is also a spirituality and purpose. The forest fire is somehow divine in Nature, all-powerful and scintillating, the pyrotechnic art of a greater Master of all things.

All four elements are constantly at work. Together they can create an endless variety of motifs: underwater grasses moving to the rhythm of music orchestrated by the current in a river; variegated mosses alive with bunchberry, Indian pipe and wintergreen; the bonsai-like, wind-shaped jackpine, struggling for sustenance in a tiny crack in a vault of rock; an incoming storm and a double rainbow; even the rampaging face of a boreal fire in itself is beautiful in an abstract way.

Spirit of Place is a hands-on experience. The natural world taunts the senses and fills the soul with wonder.

The boreal forest of Atikaki is a fire-dependent ecosystem in which all living things evolve in response to the frequency and intensity of natural wild fires. Much of the land we travelled throughout Atikaki had been razed by fire. Beyond the devastation and desolation, we witnessed new life and rare beauty in the contrast of charred stumps against the cool blue sky.

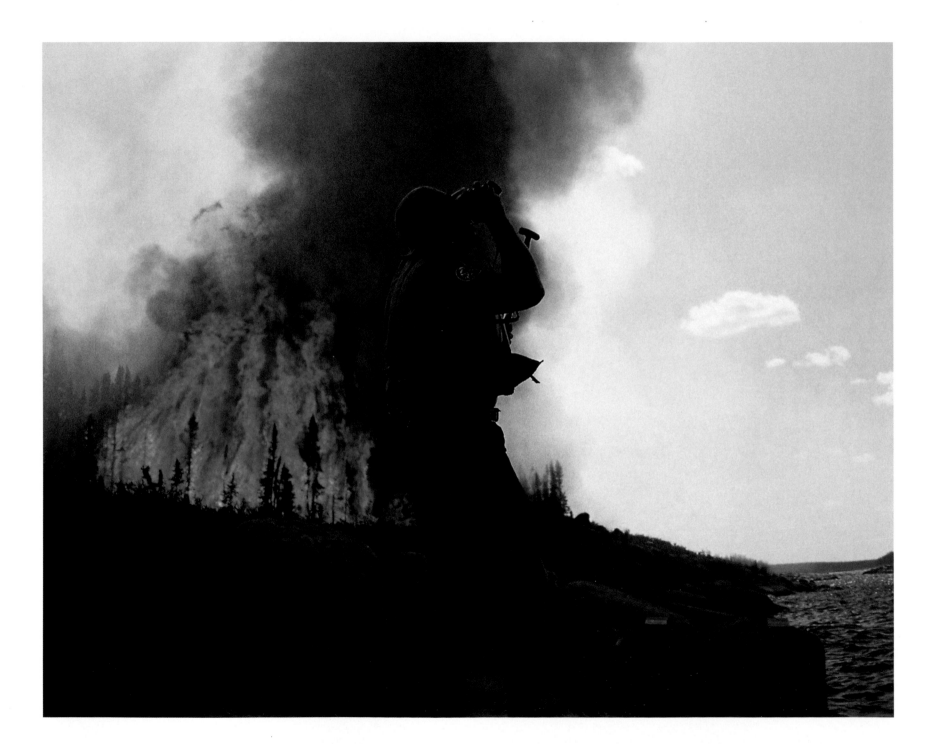

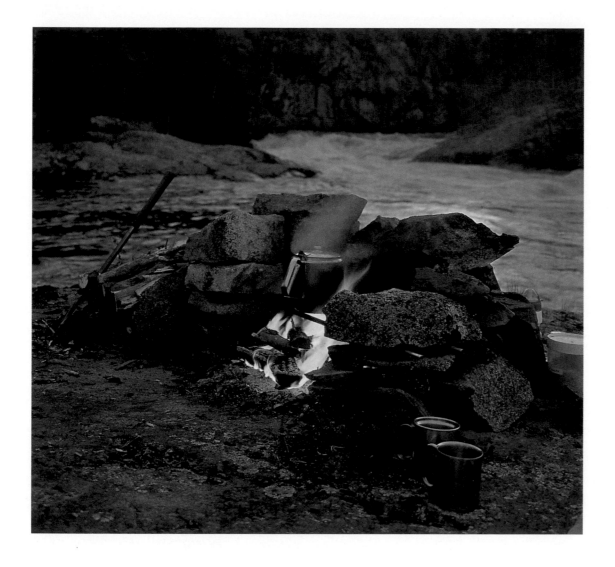

Campfire on the Berens River,
a social gathering place.

Fire is the most unpredictable of all the forces of Nature. It
is something you cannot plan for or predict. The character
of fire demonstrates its control over all living things and the
other elements: it creates its own wind and fills the air with
its smoky breath; it consumes the landscape and covers the
water in an oily patina of ash.

Rivers of Atikaki

Phantom shadows against a
Bloodvein River rock face.

ATIKAKI (PRONOUNCED A-TICK-A-KEE) IS A SAULTEAUX OJIBWE WORD MEANING "COUNTRY of the caribou." Not only is Atikaki home to several hundred Woodland Caribou, but it has also served as the homeland for aboriginal people for several thousand years. Evidence of settlement and travel along rivers flowing westward into Lake Winnipeg date back to a time when the land had barely recovered from the last ice age. The number, variety and significance of archaeological sites and rock paintings attest to the frequent use of the wilderness waterways for travel, trade, hunting, fishing, the gathering of wild rice in the fall, and for spiritual ceremony.

During the fur trade period, from the late 1700s to early 1800s, there was intensive competition for pelts by independent traders of the North West Company, who were based in Montreal, and traders for the Hudson Bay Company, who operated out of Fort Albany and later York Factory at the mouth of the Hayes River on Hudson Bay. The trading region that lay north and west of Lake Superior, as far as Lake Winnipeg, became known as Le Petit Nord, an area that fringed on the southern extremity of Ruperts Land, a vast territory held under royal charter by the Hudson Bay Company from 1670 to 1869. Although the main trade route from east to west along the Voyageur Highway

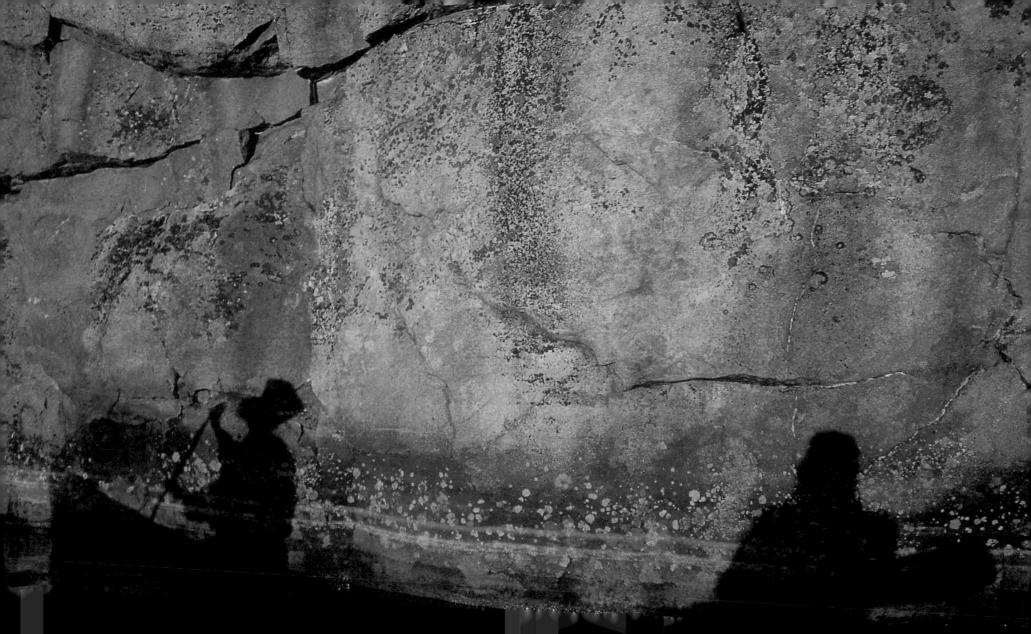

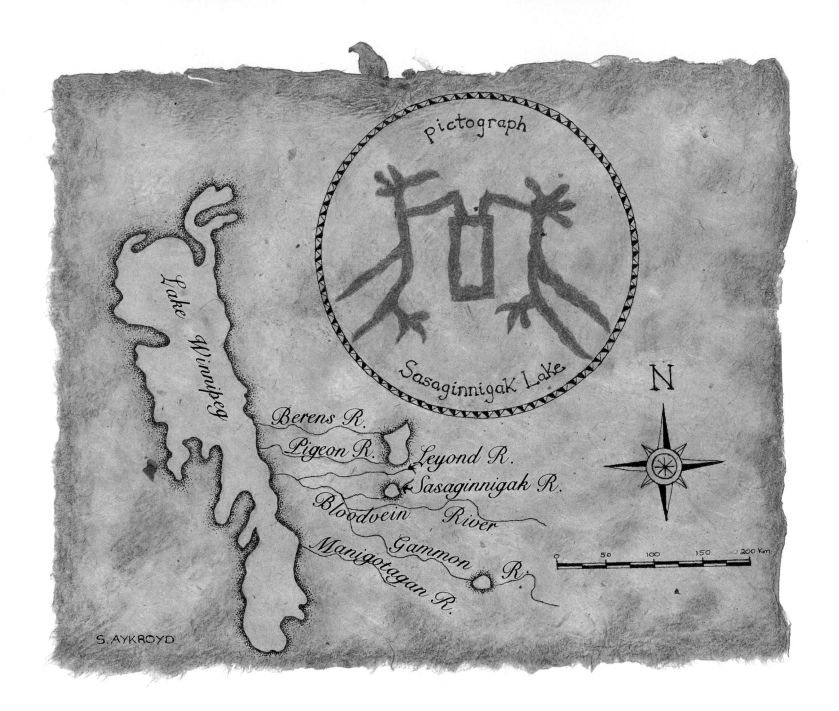

pictograph

Sasaginnigak Lake

Lake Winnipeg

Berens R.
Pigeon R.
Leyond R.
Sasaginnigak R.
Bloodvein River
Gammon R.
Manigotagan R.

N

0 50 100 150 200 Km

S. AYKROYD

followed the Winnipeg River, just south of the Atikaki wilderness, some traders used the Berens and Bloodvein routes as an alternate passage connecting western Canada with the Europe-bound boats based on Hudson Bay.

In 1985 the government of Manitoba designated a 4,000-square-kilometre area east of Lake Winnipeg, including the Pigeon and Bloodvein watersheds, as the province's first wilderness-class park. Six years later, the Bloodvein received its prestigious designation as a Canadian Heritage River for its significance in terms of human history and natural heritage, and for its potential for wilderness tourism.

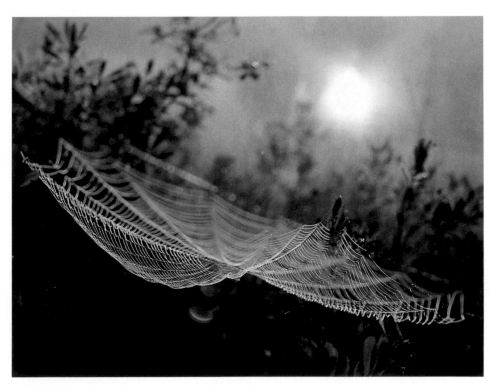

But the spirit of a river does not recognize political boundaries. Rivers flow with impunity from one province to another. The province of Ontario claims ownership of the upper headwaters of the Berens, Bloodvein and Gammon rivers, posing problems of stewardship. Both provincial governments claim to have conspired during the process of park boundary allocation, but we saw disparate differences in management of the Manitoba and Ontario lands. Manitoba practises a catch-and-release and barbless-hook policy, a responsible attitude towards protecting their angling resource; Ontario does not. Manitoba's Atikaki canoe route portages and campsites are maintained by those who use the water trails; in Woodland Caribou Park, trail maintenance is sporadic, usually under the auspices of a make-work project. (While on the upper headwater lakes of the Bloodvein River, we followed on the heels of a government portage-maintenance crew who took it upon themselves to blaze every other tree, on both sides, with a chainsaw. Ontario park politics continue to mock the true meaning of wilderness.)

Both wilderness parks are subject to various forms of resource development, particularly along boundaries. We were surprised to find that some of the best tracts of wilderness, whose forests support 100-year-old spruce and jackpine, remain totally unprotected. This nurturing ecosystem contiguous to the forests protected within

When I am on a canoe trip, I usually try and get up at least an hour before the sun. I get the fire going and put a pot of strong coffee on, ready my camera and just wait to see what unfolds. It is worth crawling out of the sleeping bag on a cold morning just to capture first light on a dew-jewelled spiderweb.

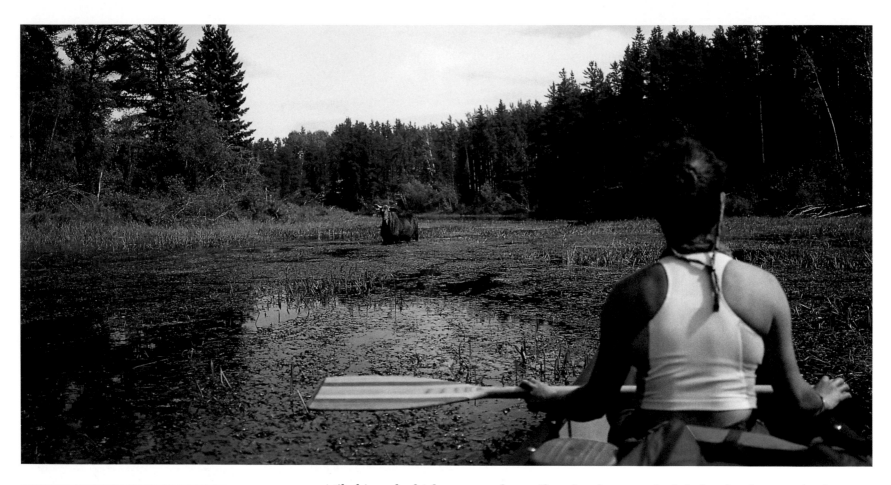

The Leyond is not a large river, and there wasn't room to paddle around this cow moose. I thought it odd behaviour when this lone cow approached us aggressively, until a calf stood up in deep grass several metres away.

Atikaki, and which support the caribou herds, was scheduled to be clear-cut in the near future. This included the lower Pigeon and Manigotagan rivers, and the whole of the Berens riverscape, all of which demand the same consideration for waterway protection as their headwaters. Although Manitoba park ideology with regards to wilderness protection is sound, any public land outside of established parks is fair game for the industrialist. Woodland caribou range throughout the glacially scoured Precambrian landscape, surviving on boreal lichens such as reindeer moss and old-man's beard, which depend upon the ecological integrity of the older forests within and around the Atikaki wilderness. Regardless of the 200-metre good-housekeeping buffer along wilderness rivers in Manitoba, in real terms, according to Manitoba Parks official Rick

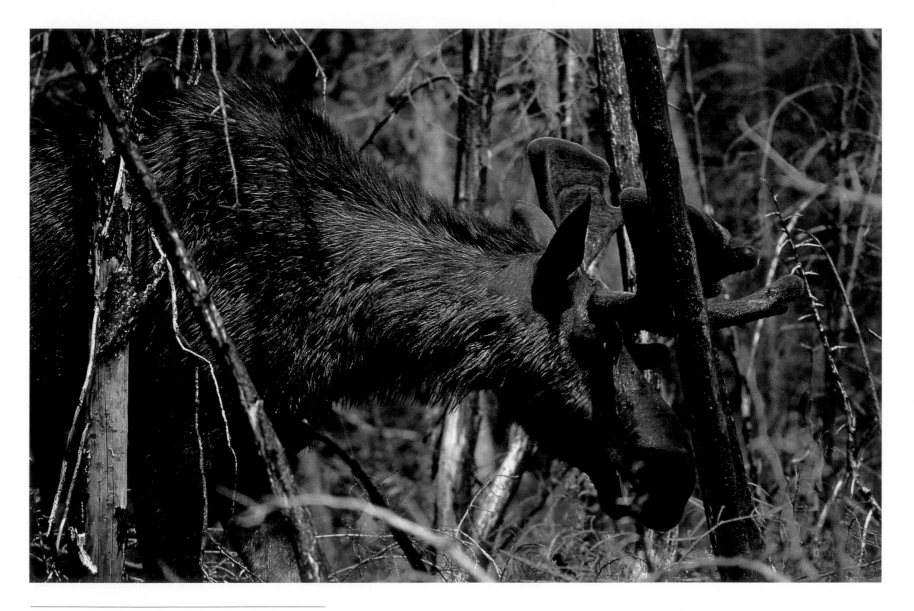

This young bull was feeding on the sedge that had grown
among the rubble of a recent Gammon River fire.

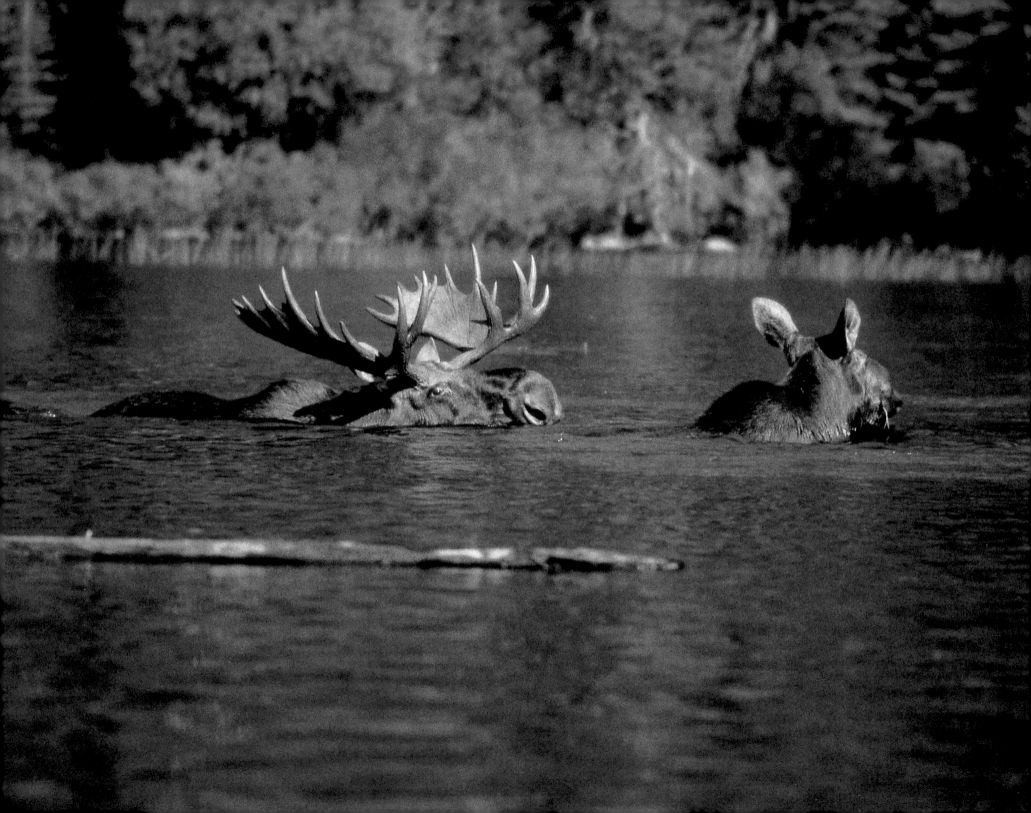

Wilson, "selective harvesting is allowed to take place within shore reserves through company sanitization projects."

Regardless of the politics governing regional wilderness, the rivers of Atikaki still provided some of the best canoeing adventures that we have ever embarked upon. Its prairie-boreal landscape has that Precambrian charm of rock and pine, blended with a primal mix of fen and boreal forest. Life adheres to the world's oldest base-rock with amazing obstinacy. Forest mosses sport collections of wildflowers and plants that beguile the senses — Indian pipe, lady's slipper and wood lily, to name but a few. Rivers flow west toward the sun, toward Lake Winnipeg and the beginning of the vast prairie veld. Innumerable whitewater rapids tumble recklessly and each bend of the river holds a new surprise. Light is diffused by stately pines and broken by rock bluffs. Nature is close enough to embrace. There are rock-art sites, mysterious and inspiring, painted by native shamans almost 2,000 years ago. The Atikaki wilderness is a place of ceremony and celebration, of timeless stability with an artistic balance between the elements.

A bull moose pursues a young cow; part of the fall mating ritual.

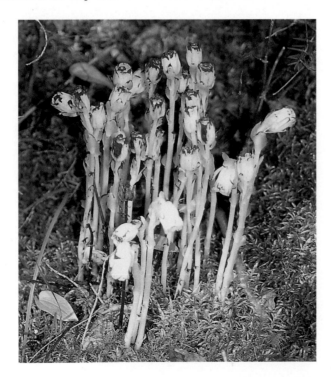

Indian pipe is a member of the herb family and receives its sustenance through fungal connections from its roots to those of nearby trees. It was used by aboriginal peoples as a remedy to soothe and heal sore eyes. It is also known as the "corpse plant" because of its ashen colour, or "ice plant" because it dissolves like ice if rubbed.

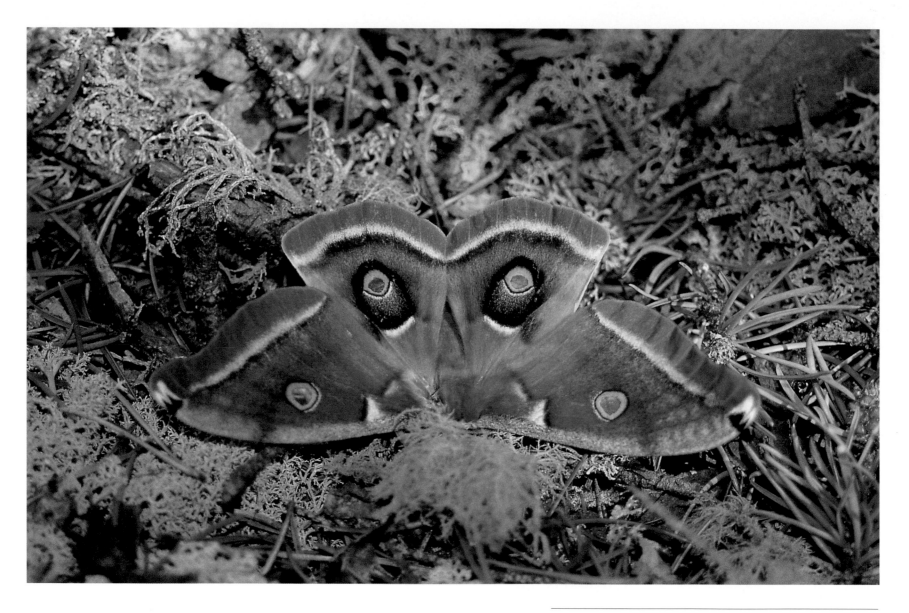

The magic of Big Moose Falls on the Berens River charmed us
into staying an extra day. I was standing on the needle mat
below a large jackpine at our tent site when I realized I had
almost stepped on two enormous polyphemus moths perched
neatly by my feet, taking advantage of the morning sun.

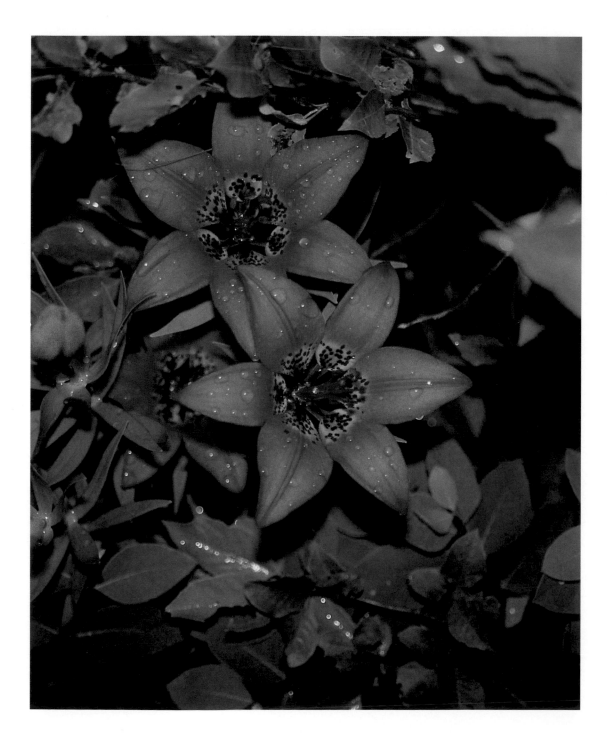

We had just finished setting up camp at the head of a portage on the Manigotagan River when an intense thunderstorm hit us. As quickly as it arrived, it departed. The sun appeared and a magnificent rainbow arched across the falls below. As I walked the portage to admire the rainbow, I was captivated by the beauty of these wood lilies growing by the water's edge.

Lessons in Rock

Shaman artists carried on the tradition of picture writing because they wanted to convey a message or instruction. These cliff sites were considered sacred, as they were the homes of the manitous, places where the underworld greets the heavens. There may be a simple scientific explanation concerning the ability of the paint (a mixture of powdered red ochre and fish oil) to withstand the elements, but on a more spiritual level, it could be seen as using the blood of resident spirits, the memegwishiwok, to bond the figures to the rock face. Such pictographs, some up to 2,000 years old, still continue to baffle scientists.

German art historian Herbert Kuhn claimed that "by the symbolic 'killing' of the animal, or enemy, the hunter would anticipate the success of the hunt and death of the target entity." Kuhn was referring to the Lascaux Cave paintings in France, but Canadian rock art falls under similar theory.

The Artery Lake pictographs on the Bloodvein River, pictured here, is best viewed in the evening, under soft light. Famed archaeologist Selwyn Dewdney writes about bison image: "The site is perhaps a hundred miles north of the parklands where the bison herds once roamed, but the artist shows a familiarity with the animal that suggests either frequent hunting excursions southward, or his own southern origin."

Dewdney also made the startling discovery that the oval hooves were given the exact same treatment on the Lascaux Cave paintings, thousands of miles away.

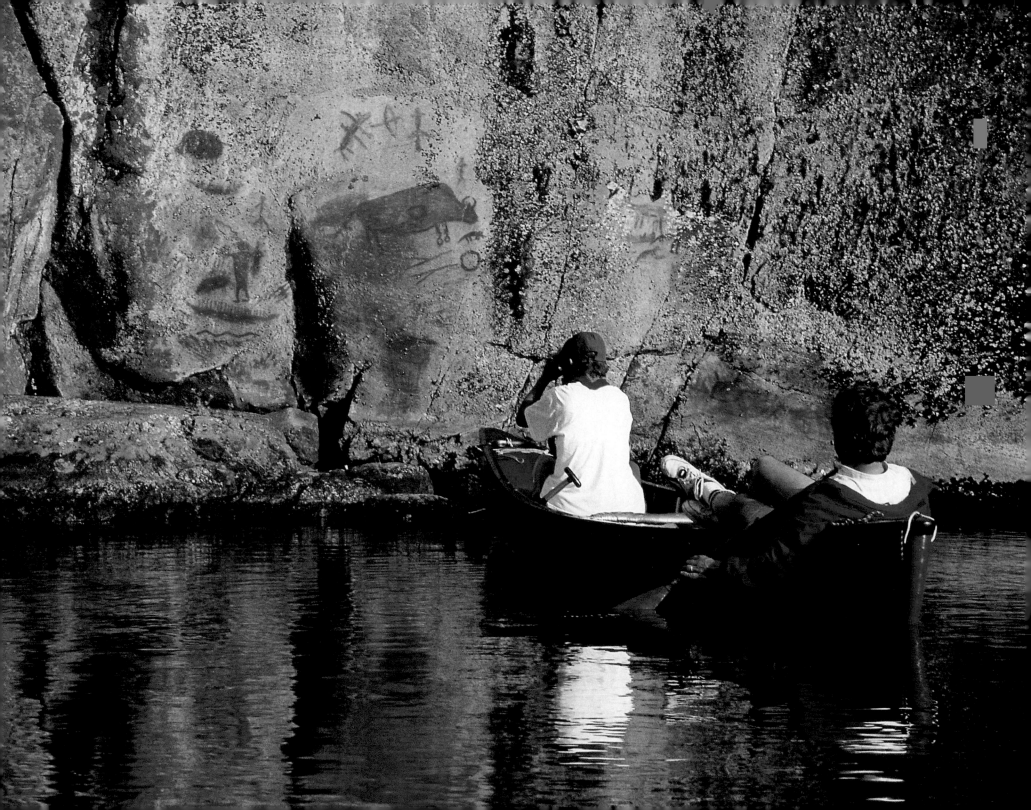

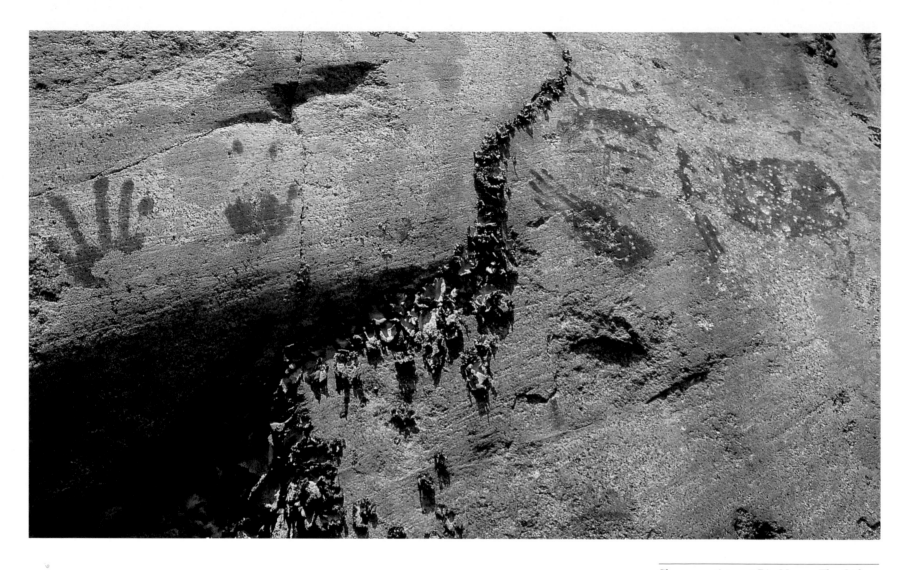

Shaman artistry at Big Moose. The Ojibwe
still leave offerings of tobacco here.

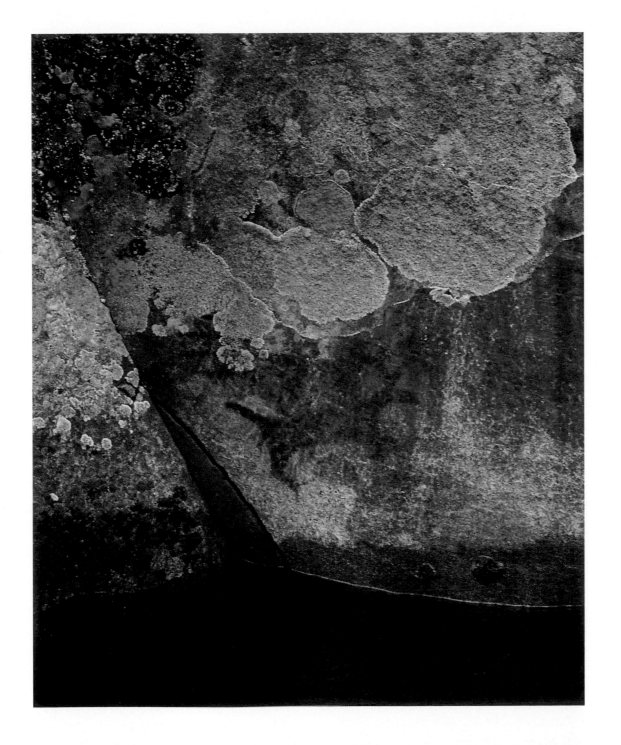

Lichen growth creates its own art among the
warm tones of the red ochre paintings.

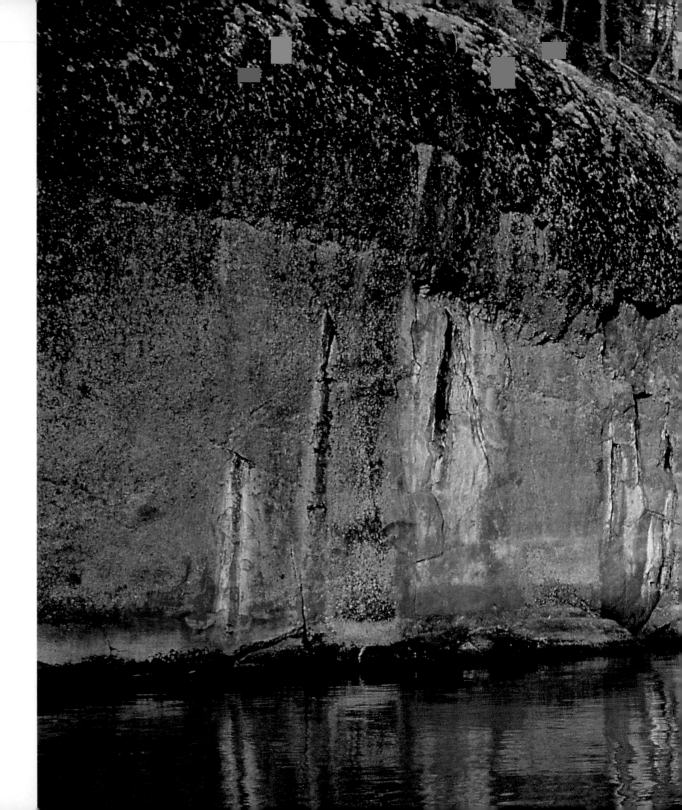

Evening light captured on a wall of
rock art on the Bloodvein River.

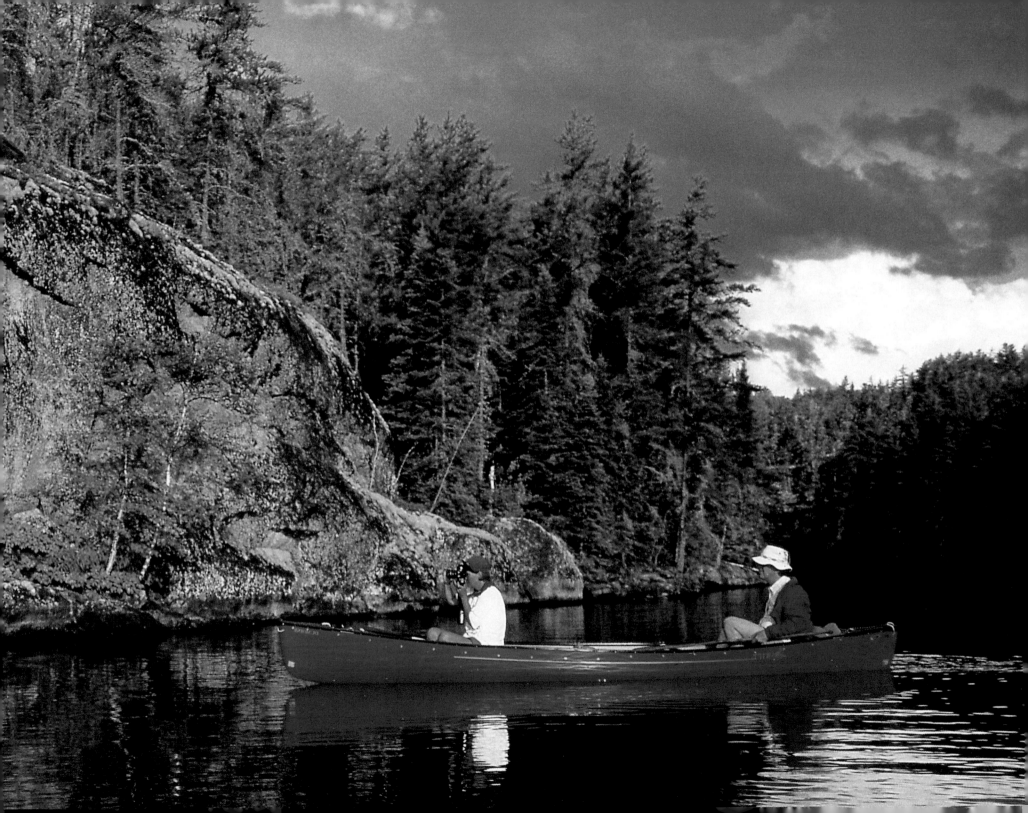

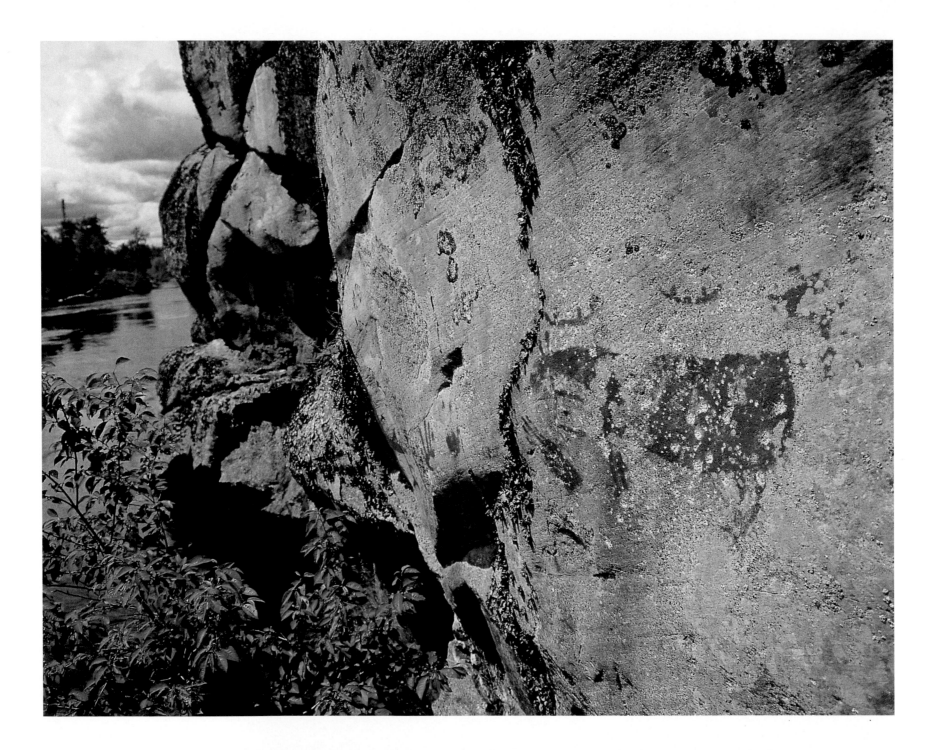

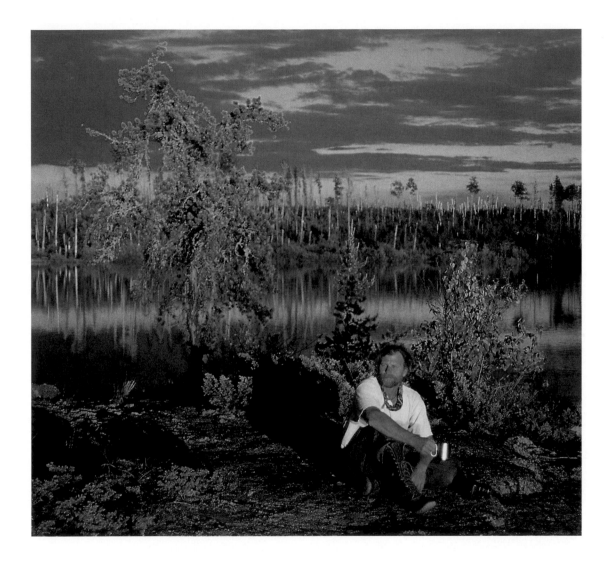

The ochre glow of the evening light sets an ambient mood for a hot cup of bush coffee at a Berens River campsite.

Pictographs at Big Moose Falls, Berens River.

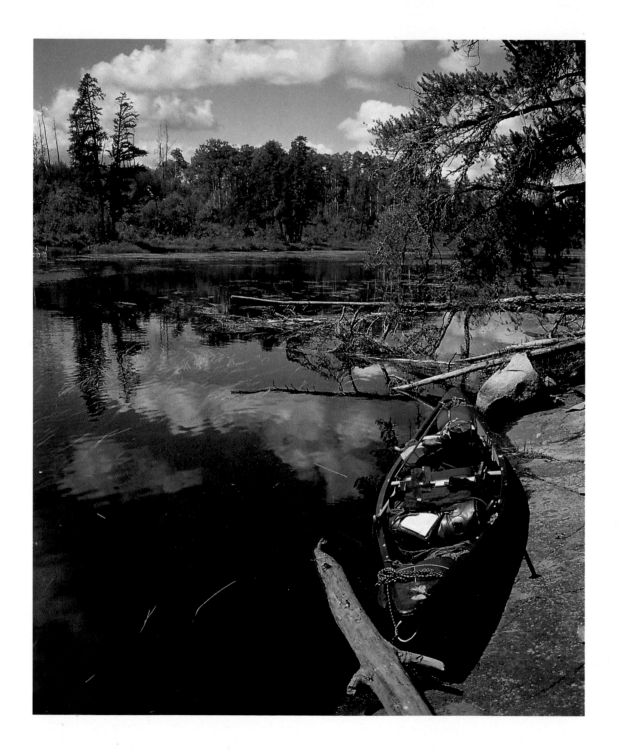

A moment of repose on the Gammon River. The typical nature of the Canadian Shield pool-and-riffle-type river: sedate and refined one moment, pretentious and cavalier the next.

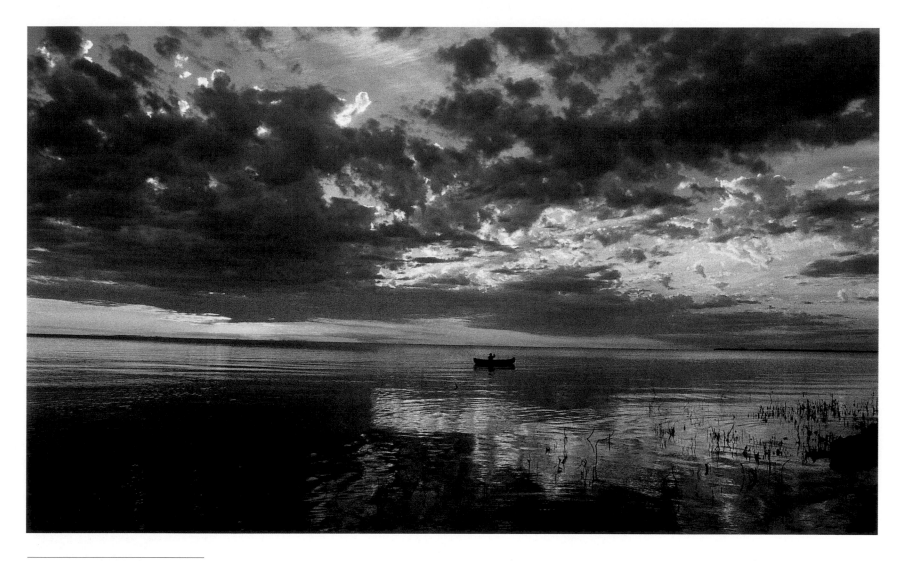

Sunset over Lake Winnipeg — an
uncommon moment of calm.

The Middle Track

NO OTHER RIVER CORRIDOR FLOWING INTO THE GREAT NORTHERN SEA BEQUEATHS AS colourful a history as does that of Manitoba's Hayes and Grass rivers. The Churchill and the Nelson, the only watercourses larger than the Hayes, have been forever silenced by hydro-electric development, but the Hayes has escaped this fate and remains, to this day, virtually as pristine as it was when Hudson's Bay Company traders first plied its waters in the 1600s. Manitoba Hydro is still considering a project that will divert the entire Hayes flow northward to join the Nelson River.

Looking back, the Hayes was a natural gateway corridor to Canada's interior and would gainfully serve the Company for more than two centuries. The York Factory post was established at the estuary of the Hayes River in 1684 and quickly became the central collection and dispatch depot for the fur trade, continuing to operate until 1957. The post is now an artifact museum designated as a Canadian Heritage Site and operated seasonally by Parks Canada.

Pays du Rat, or muskrat-country, as the Grass River region was known to early voyageurs because of its bounty of muskrat and beaver, became a secondary route west. The Grass had a quiet demeanour compared to the brisk current of the middle Hayes

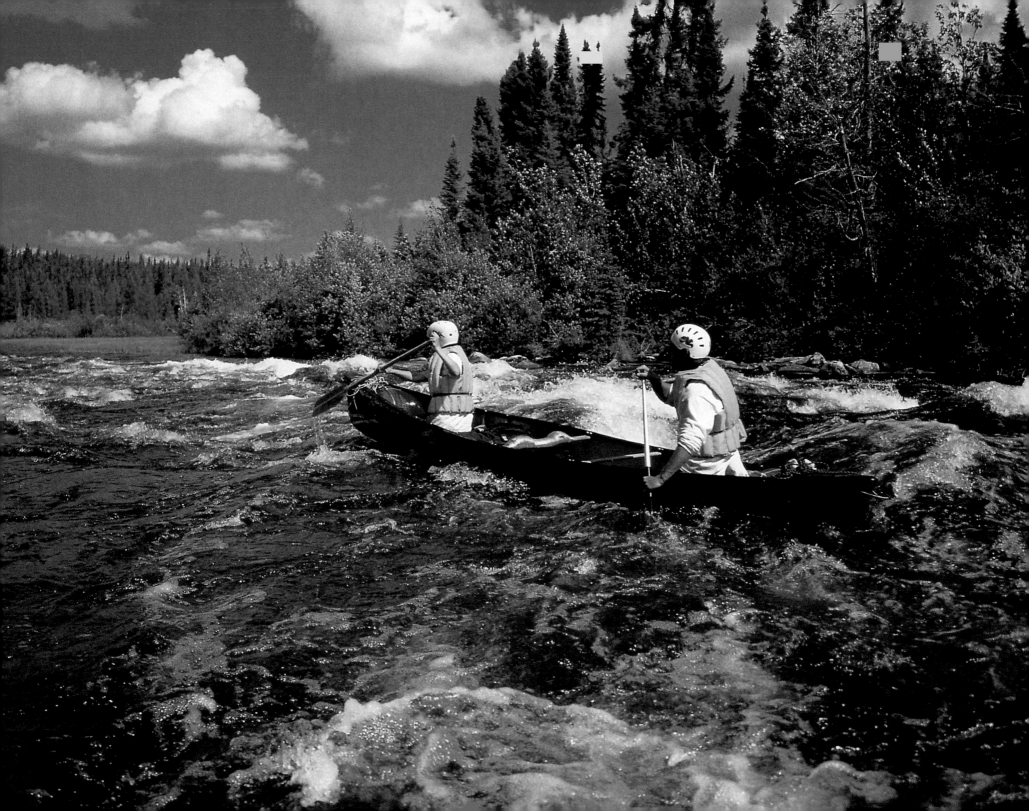

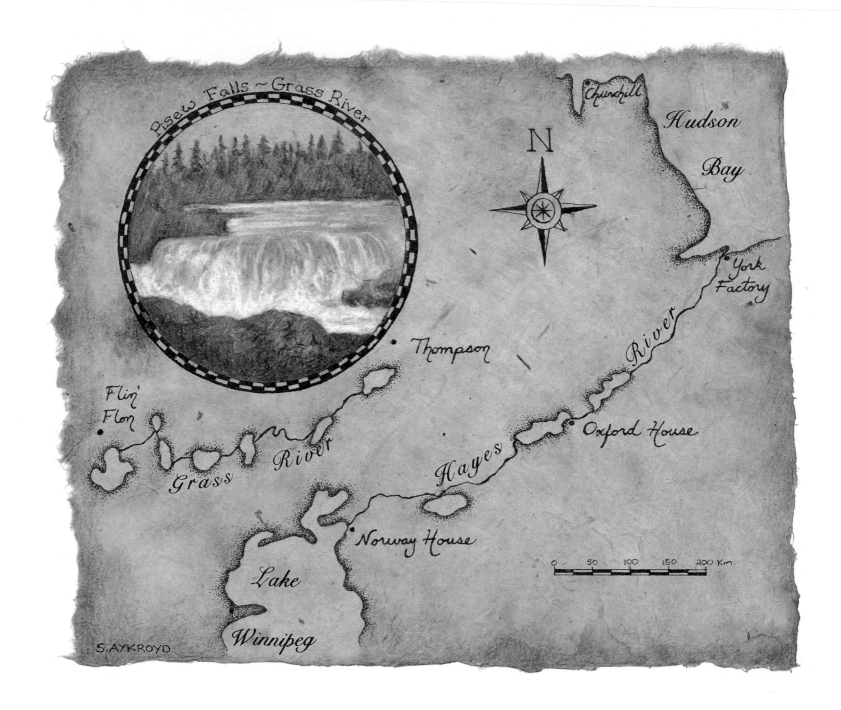

Pisew Falls ~ Grass River

N

Churchill

Hudson

Bay

York
Factory

River

Thompson

Flin
Flon

Oxford House

Grass River

Hayes

Norway House

0 50 100 150 200 Km.

Lake

Winnipeg

S.AYKROYD

and the upper Nelson. The Echimamish River, which connected the Hayes to the Nelson, often had barely enough water in it to float a York boat or loaded canoe. For these reasons, an alternate low-water route became essential to maintain the steady flow of traffic and furs. Eventually, the Hudson's Bay Company built a series of log dams along the Echimamish to ensure water level. The remains of these dams can still be seen today.

For three centuries, explorers, traders and geologists travelled inland on the middle track: Radisson in 1682, Henry Kelsey in 1690, David Thompson in 1794, the ill-fated Franklin expedition in 1819, George Simpson in 1824, and famed geologist J. B. Tyrrell in 1892. Samuel Hearne pushed his way up the Grass River in 1774 and established Cumberland House, the first inland Hudson's Bay Company post on the Saskatchewan border.

Our own canoe trip down the Hayes River, a distance of 650 kilometres from Lake Winnipeg to York Factory at Hudson Bay, took twenty-six days to accomplish at a comfortable pace. Even at that rate, and despite being weather-bound on several occasions and working the many rapids in high-flow rather conservatively, we were thoroughly enervated by the time we reached the Bay. In 1828, chief factor Archibald McDonald of the York Factory Hudson's Bay Company post accompanied Governor Sir George Simpson on his cross-Canada canoe journey. Leaving from York Factory, they took just eight days to reach Lake Winnipeg — an arduous upstream trek at an average speed of 80 kilometres a day.

But times were different then. Travel by canoe was purely for commercial purposes and missing the last boat bound for Europe before the long winter set in was tantamount to a crime against survival of self, community and Company. We had

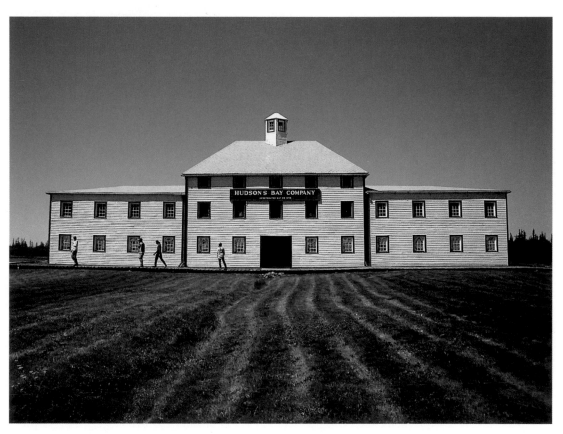

York Factory post, a monument to the fur-trade era.

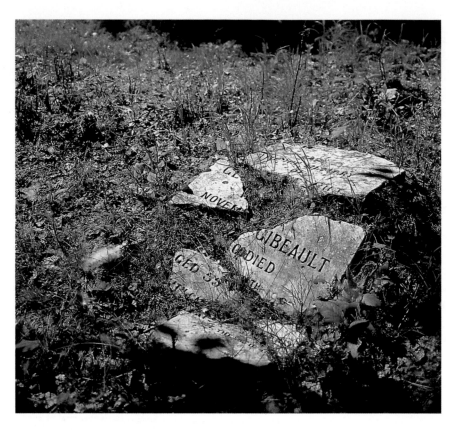

Graveyard at York Factory.

Facial expressions tell all in this photo. At the time we were paddling the last expanse of Knee Lake on the Hayes against a persistent wind, following close to shore and taking advantage of any windbreak.

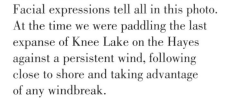

techno-gear; they had sheer determination, stamina and four drams of Company rum per day. It is a sobering thought to consider that most canoemen of the time died at least ten years before my now relatively young age! Life was short for these stalwart men. Archibald McDonald wrote in his trip journal: "...and poor fellows, they are always ready, and cheerily jump up to their work, and out of their heavy and so well earned sleep of four, or at most five solid hours in the twenty-four. They know nothing of an 'eight hours' movement, and don't dream of it: eighteen hours is the labour time, and that of the hardest."

Writing about the speed at which they covered distance by canoe, McDonald noted: "The average rate on still and calm water was from 5 to 6 miles per hour, but the Governor's rate was always a little more. Ninety miles was his average on some routes, i.e., downstream."

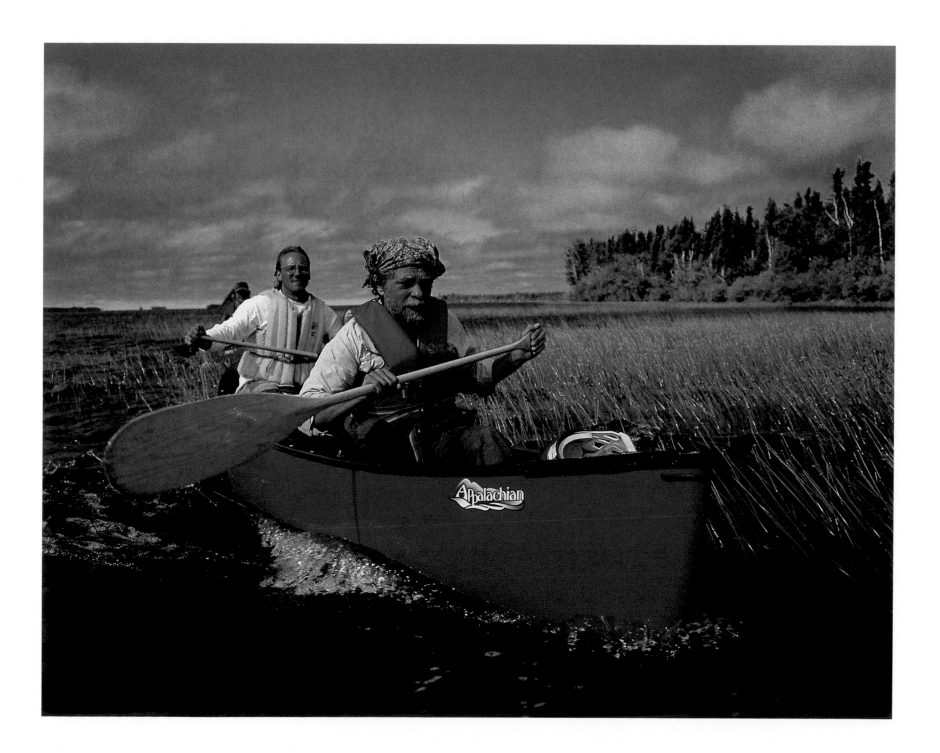

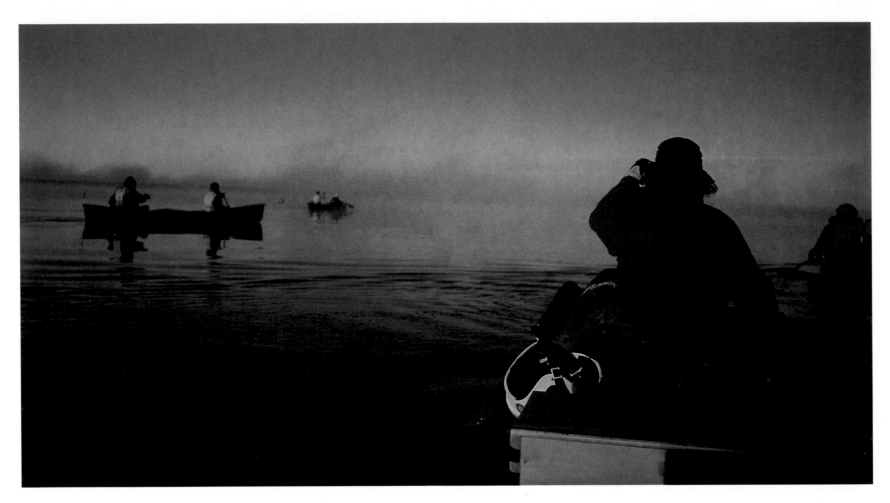

The chilling ghost fog off of Hudson Bay obscures the shoreline as we search for York Factory at the end of the Hayes River.

This obsession with time, spawned by a vigorous trade war over furs, accentuated the differences between native people and white traders. In time, the aboriginal people along the trade routes — in this case the Cree — relinquished many of their traditional practices and became almost wholly dependent on the "post" for their needs, while white explorers and traders relied on homeguard Indians for furs, meat, and guiding services. Neither one trusted the other.

The Europeans believed the natives to be lazy and apathetic, probably because they were not motivated by profit. The term "savage" came about because of their pagan beliefs and impassioned barbarism in battle. The Cree, on the other hand, believed the

white man to be stupid, untrustworthy and spiritually challenged: they could not survive alone in the wilds, designed their own failures with peculiar regularity, and displayed total impiety to the land.

The colonial attitude confounded people of the First Nations. This avaricious posture had the most profound effect on the spiritual beliefs and ceremonial practices of the Cree people. Disparately opposing work ethics and religious faith between whites and *savages* was never more apparent as exemplified by the destruction of the Cree altar at Painted Stone portage, located at the height of land that separated the Hayes from the Echimamish and Nelson. In 1786, David Thompson commented on the Painted Stone and its subsequent destruction by his men: "On the short carrying place by which we crossed this ridge, the Indians, time out of mind, has placed a manito stone in shape like a cobbler's lap stone but three times its size, painted red with ochre, to which they make some trifling offerings... the stone and offerings were all kicked about by our 'tolerant' people."

Thirty-three years later, Franklin remarked about the site in his own journal: "It is said that there was formerly a stone placed near the centre of this portage on which figures were annually traced, and offerings deposited, by the Indians; but the stone has been removed many years, and the spot has ceased to be held in veneration."

Once these sacred places of harmonic convergence, where the corporeal world melds with the supernatural, have been desecrated, the spirit forces are believed to move on. We, like Franklin, looked for the treasured painted stone altar, to no avail. It had probably been tossed or rolled into the morass of organic ooze below, adjacent to the end of the portage trail.

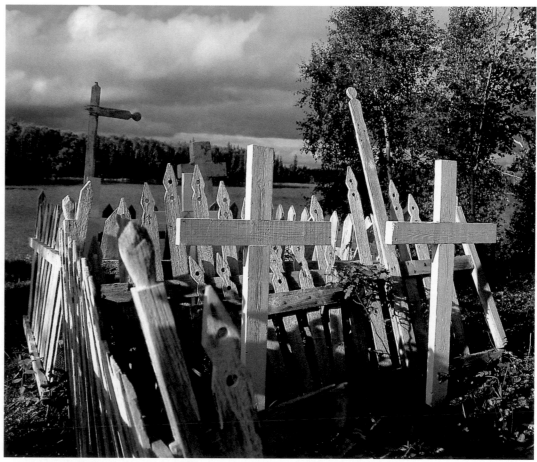

This Cree graveyard on the Grass River near Setting Lake is still maintained by the local Swampy Cree Nation.

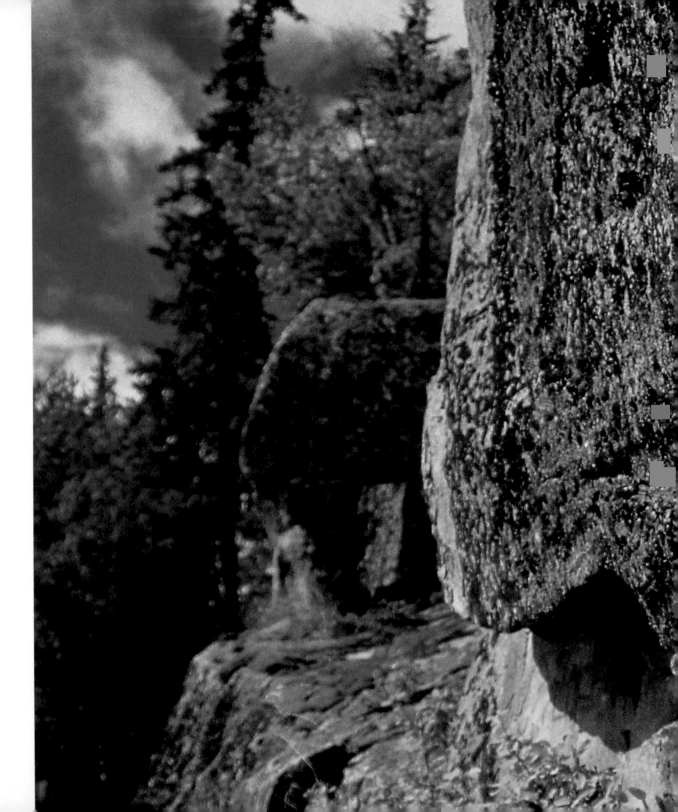

These pictographs found on Tramping Lake, on the Grass River, are considered to be of international importance.

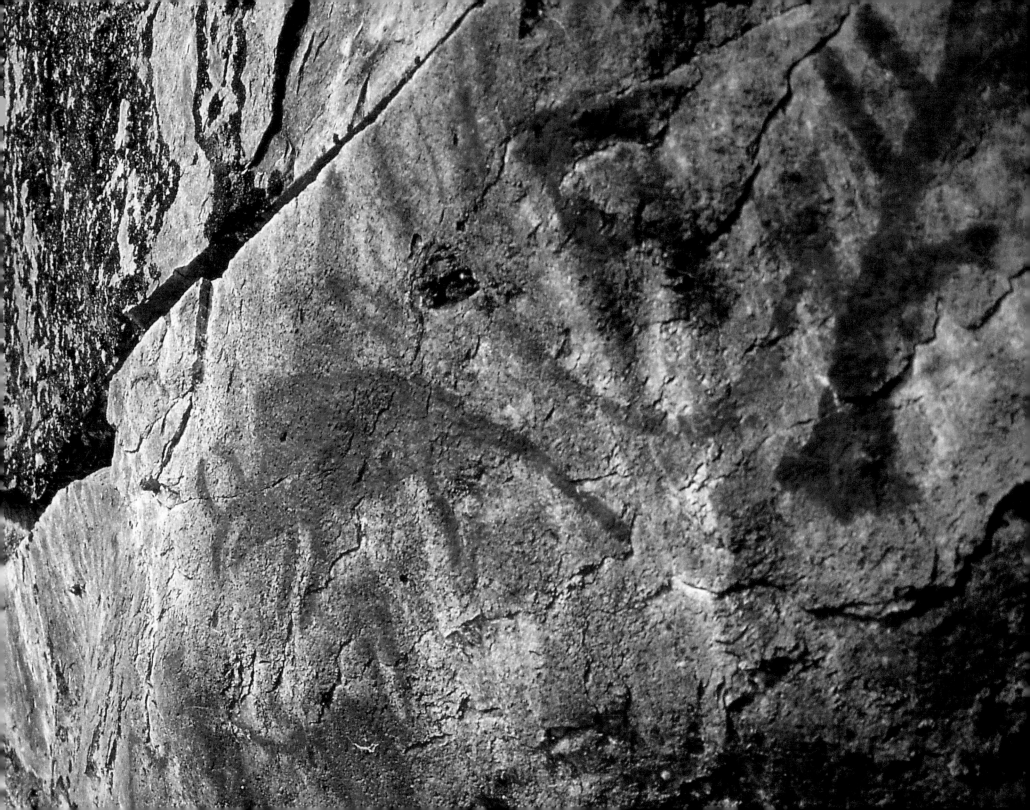

Farther into the interior, well up the Grass River, lies Tramping Lake. A typical lake, except that it is home to Manitoba's most astonishing display of pictographs, a dramatic account of the early teachings of ancient medicine healers or shamans. Of all the rock art sites we visited across the province, the figures on this stone palette were by far the most vivid and mysterious, not confined to the usual course of rock reached from a canoe perch, but decorating granite faces that rise many metres above the surface of the lake. Graffiti has been painted across some of the ancient figures. The men who perpetrated this heinous crime lived and worked in the local mining community and often took their motorboat onto the lake to drink beer and fish for walleye. "They're both dead now," Tony Brew from Wekusko Lodge informed us. "One died in a violent car crash, and the other, he died in a mining accident."

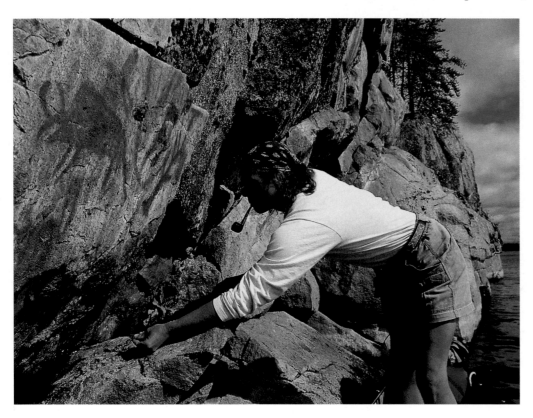

The Tramping Lake pictographs on the Grass River are perhaps too accessible and have been defaced by white graffiti. We left an offering of tobacco as a token of respect.

Strange deaths had occurred at other sacred sites that I visited in the past — along the Missinaibi River in Ontario, at Agawa Rock and Fairy Point, and at Thunderhouse Falls, each with their own supernatural tale to tell, and each the location of deaths and drownings of a mysterious nature.

Crimes of the white man aside, it's hard not to feel a sense of awe when you consider the Herculean feats of human endurance and hardship early settlers suffered while ascending the Hayes River. One of the most remarkable events took place between 1811 and 1815 when Lord Selkirk moved supplies and homesteaders, even farm equipment and livestock, up the Hayes and down Lake Winnipeg to the settlement at Red River. Having paddled down the river ourselves, playing the rapids and ledges with some trepidation, fending off hordes of mosquitoes and black-flies, we could only imagine how difficult the trip must have been for Selkirk's immigrants. Our own discomforts seemed trivial.

We were just loading our canoe from the campsite on a rock terrace above the Grass River near Tramping Lake when this scene caught my interest. Every time I look at this picture I can smell the damp aroma of bog-laurel and cottongrass.

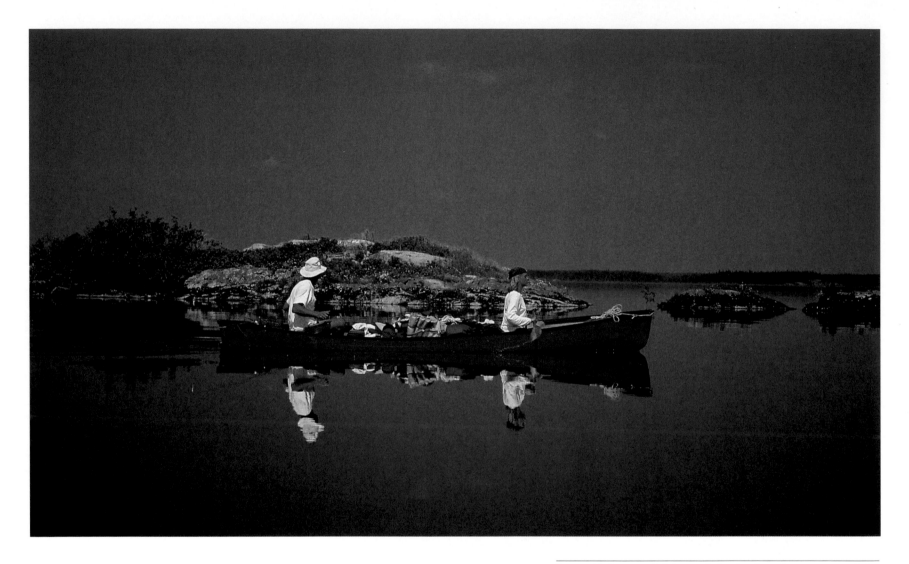

It was 30 degrees Celsius and dead calm when we crossed the
wide expanse of Oxford Lake on the Hayes. This weather
allowed us to island hop instead of hugging the shoreline.
I can still feel the heat when I look at that canoe.

We encountered bald eagles, the occasional moose and caribou, but few visible reminders of an era now relegated to the pages of history books. The only sign of recent human passage was the broken carcass of a Kevlar canoe, pinned against a boulder in the middle of Knife Rapids. It was hard to envision this river as once being a roistering avenue of activity.

Ecologically, the Hayes is unique in that it blends two distinct ecozones, the Precambrian Shield along the upper reaches, and the Hudson Bay lowlands. Weather and geological forces have dramatized the setting, with cascading rapids, waterfalls and unspoiled lakes typical of the top two-thirds of the river. The lower course rushes through that interminable morass of boreal slough that terminates at the edge of the great northern sea. We drifted along with the current under the aura of the northern lights, traversing lakes so enormous that our navigational aid was the sky itself. The images and motifs were endless, the opiate of adventure guaranteed.

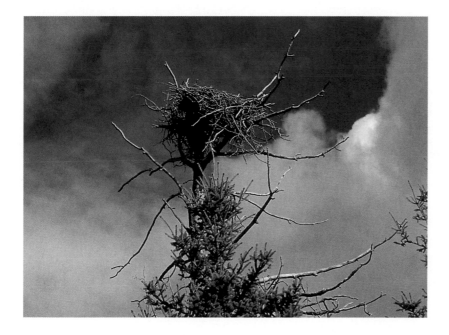

This lofty domain of a bald eagle resides just off a portage trail on the Grass River. Eagles are as common here as ravens, herons or blue jays.

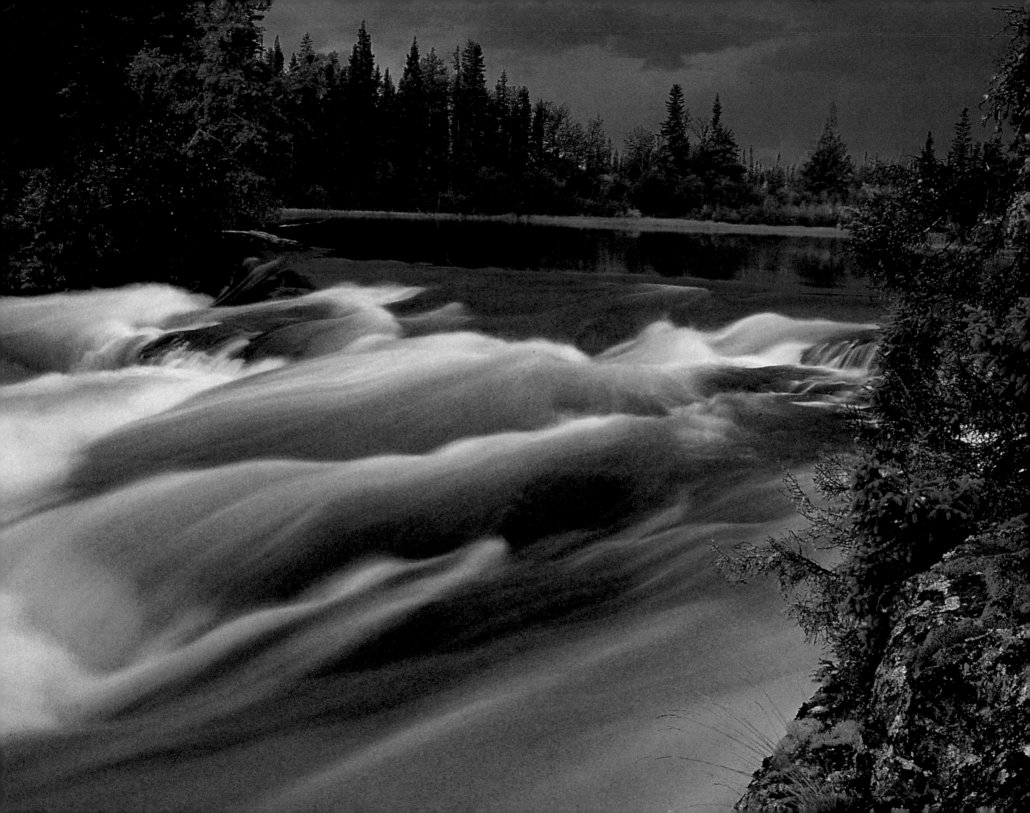

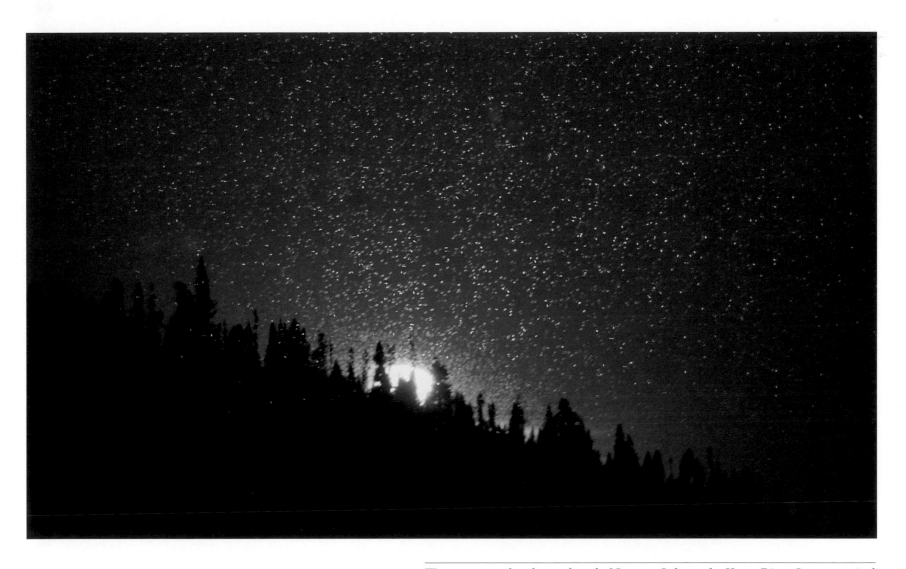

We were camped at the south end of Swampy Lake on the Hayes River. It was a typical July evening except for the swarm of mayflies filling the evening sky in a mating frenzy. Born without mouth parts or digestive systems, their short-lived appetite is completely carnal in nature. I took advantage of the situation. The sun, just about to drift below the skyline of spruce, looked more like a ball of fire throwing sparks into the heavens.

The Grass River remains rather good-natured as it slowly rounds a bend, but its demeanour is quickly altered as it tumbles through the rapids above Whitewood Falls.

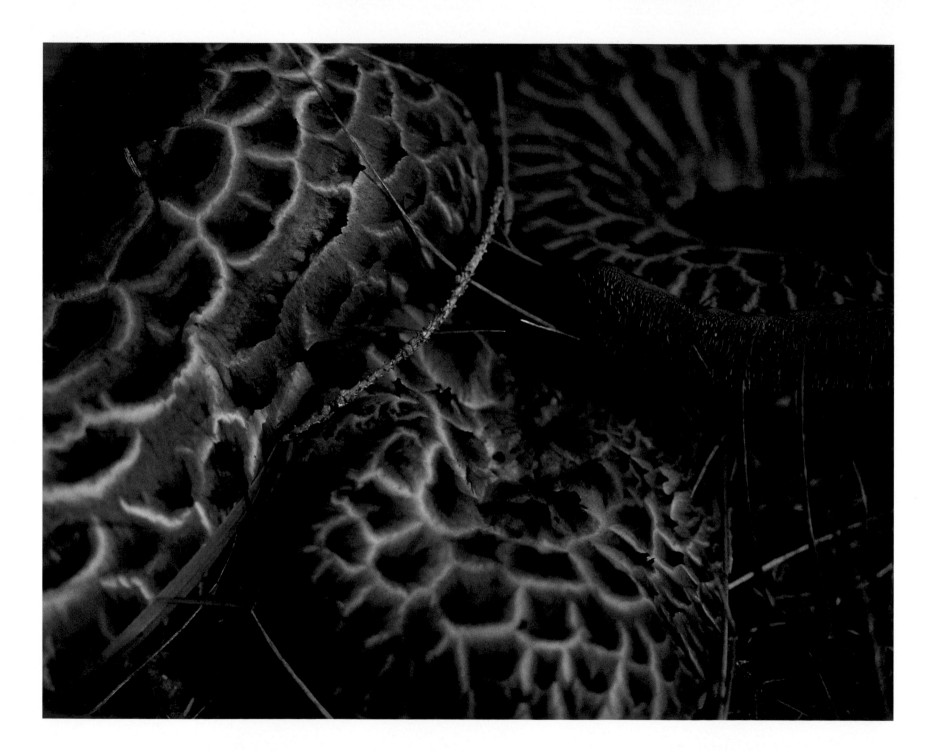

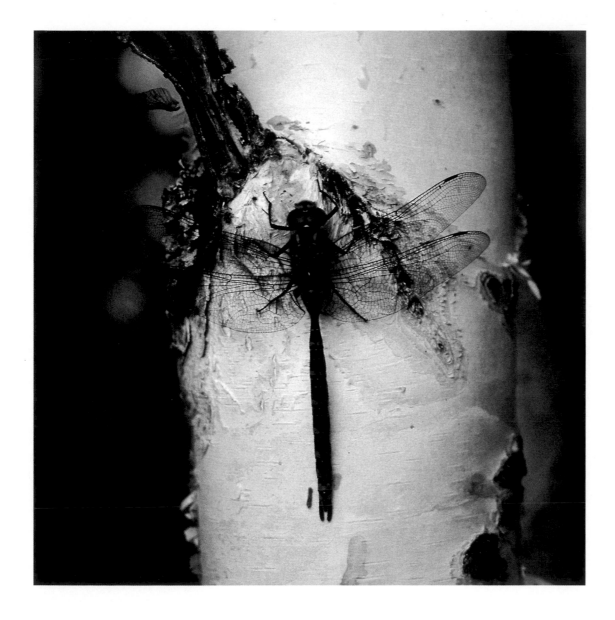

A dragonfly finds respite from the wind in a copse of young birch trees.

By removing the subject border, this *hydnum imbricatum* fungi looks more like a coiled snake. It's beautiful to look at but much too tough and bitter to eat.

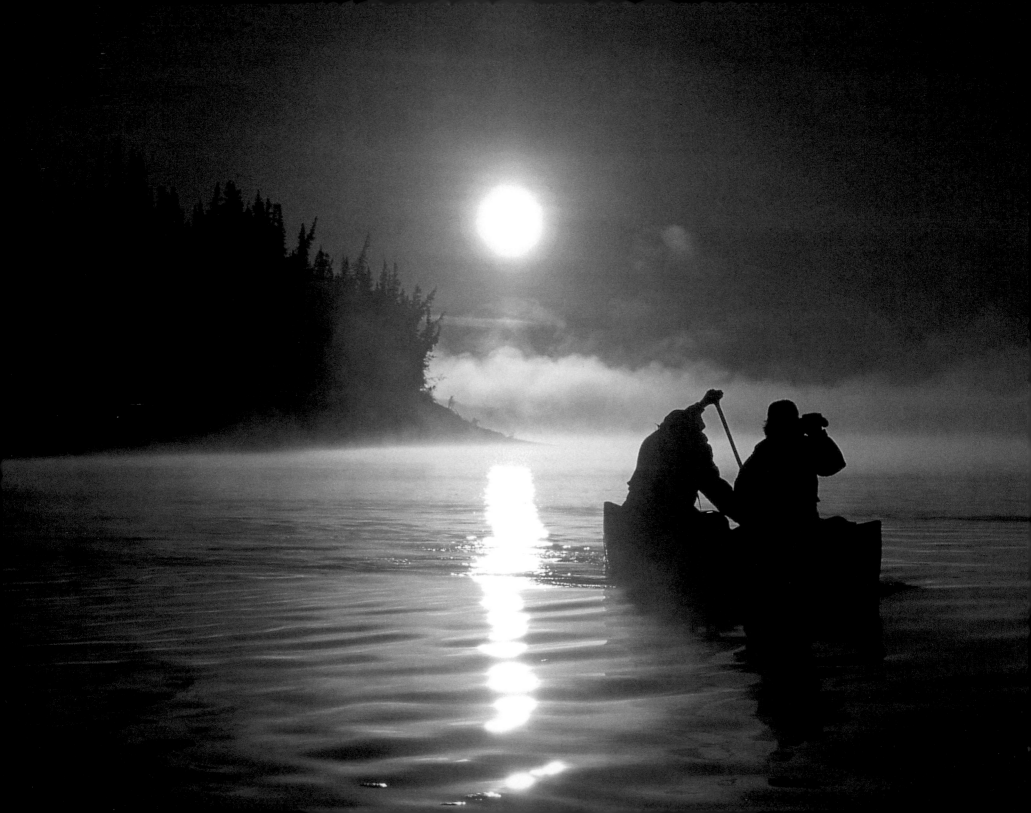

Sunrise over the Hayes River
estuary at Hudson Bay.

Looking back over the Echimamish River, the historic link between two great Manitoba rivers, the Nelson and the Hayes.

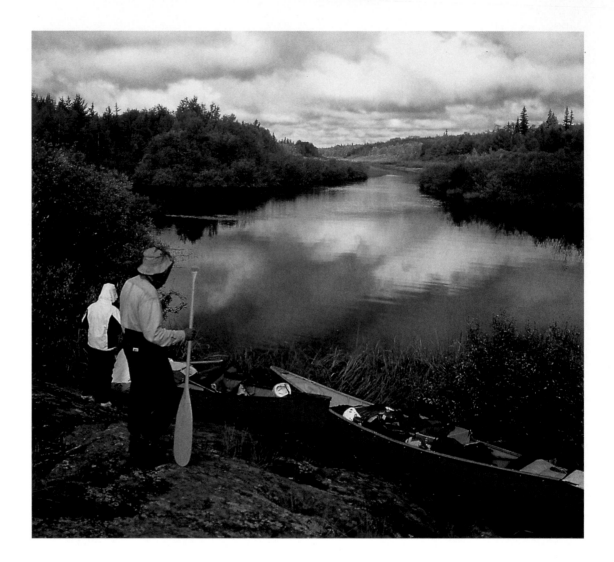

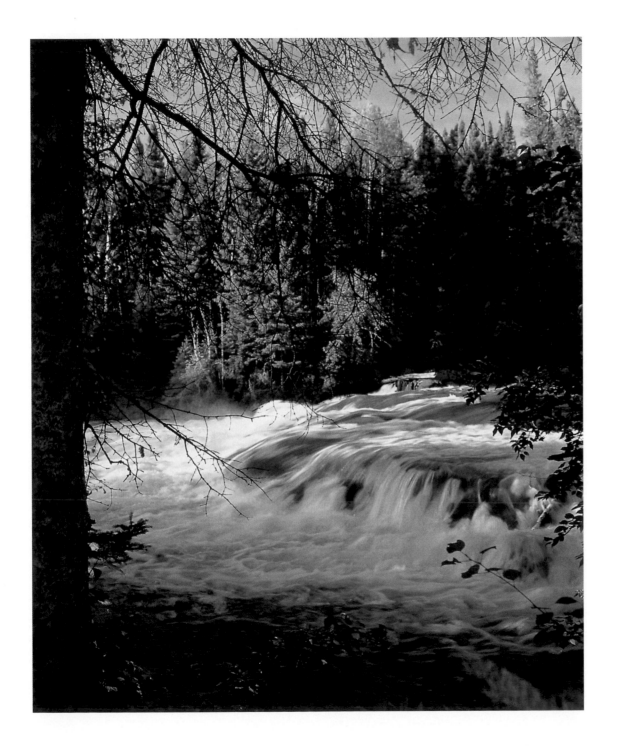

Magnificent spruce forests and resplendent waterfalls and cascades characterize the Grass River.

Trapper's Cabin on the Hayes River,
pencil sketch, Stephanie Aykroyd.

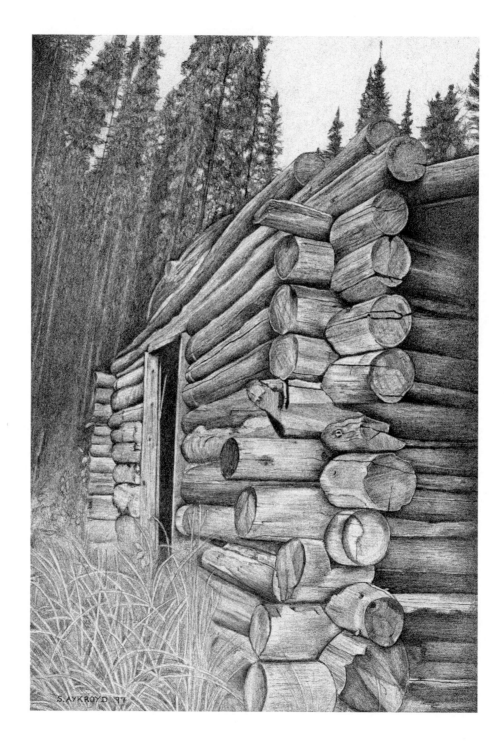

This spongy sphagnum mat is typical boreal carpet throughout the middle Shield ecozone. Wild berries such as the bunchberry thrive in this zone, providing food for ptarmigan and grouse, while the cover provides a home for the pygmy shrew. Sphagnum was used by aboriginal people for a variety of things, including diaper padding for inside infant cradle boards and as dressing for wounds. Sphagnum has amazing absorption capabilities and inherent antibiotic properties.

Land of Little Sticks

Overlooking the Thlewiaza River from atop a 100-metre-high sand esker.

"This portage passed over three-quarters of a mile of extraordinarily forbidding and sterile country. The sand ridges gave way to barren, stony, morainic hills, some of these solid masses of gray, lichen-colored boulders and shattered fragments of rocks. The trees had been burned off some time previously and had not grown up again. It was all very grim. The rolling, gray waves of rock, the fire-blackened, dead spikes of spruce, the gleaming white ghosts of birches all backed by a lowering dull sky streaked with rifts of lighter gray added a Goyaesque touch to the scene of abandonment and desolation."

— from *Sleeping Island*, P. G. Downes

WE HAD JUST FINISHED PADDLING A RATHER TEDIOUS PIECE OF THE THLEWIAZA RIVER, long stretches of flatwater with a recumbent shoreline devoid of character and choked with water sedge, leatherleaf and bog laurel. There were a few bouldery rapids and these we ran with the spray-covers attached. The Dene had good reason to call this Big Water River. The maw of standing waves and crashing boils were threatening, large enough to swallow an open canoe at the first assault. Stephanie and I ran first, then

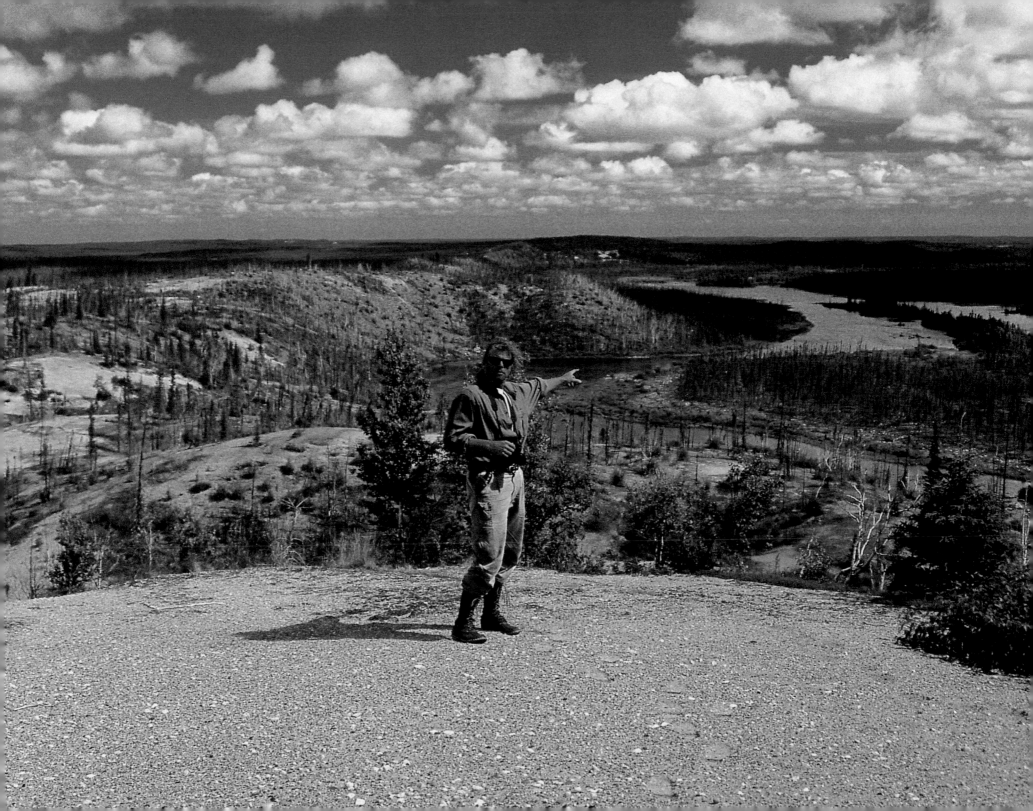

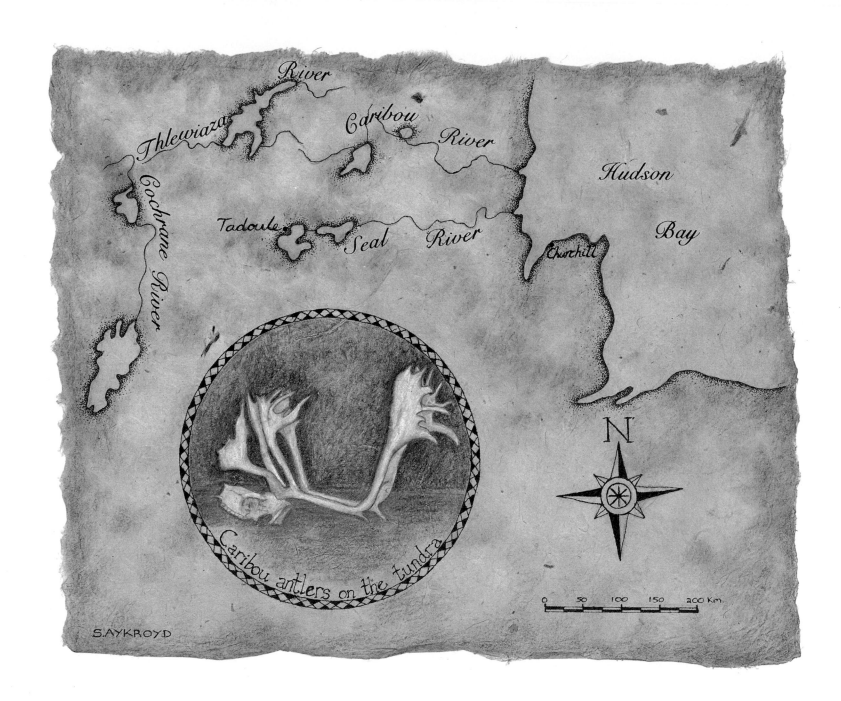

Caribou antlers on the tundra

S. AYKROYD

gave Jöri and Walter the signal to follow when we reached the bottom eddy safely. Other, smaller rapids required a quick eye and deft movements, precise draws and pries, backwater ferrys and steady braces that commanded much of our remaining energy. It had been overcast for most of the day and a light drizzle chilled the air. There was no suitable place to pitch our tents and dusk was quickly settling in. The shorelines retreated as we entered the first traces of treeless heath, accented by stony moraines and scabrous vegetation. The few trees, mostly black spruce, were stunted and no more than two to three metres tall. I had yet to witness a Manitoba landscape as desolate and forboding as this one.

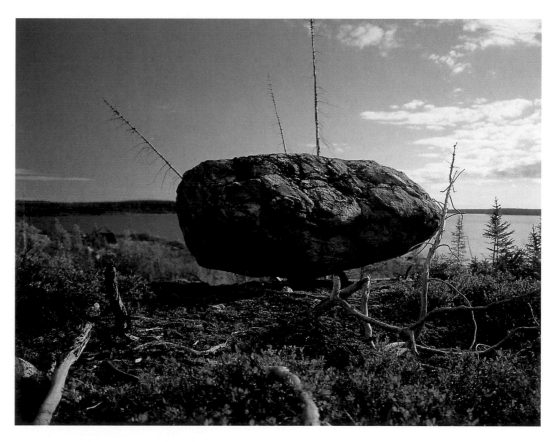

The river suddenly opened up into a long lake. To our left was a low, rock-strewn rise, some distance out of our way. Having few other options available to us, we headed for it. It proved reasonable enough, if only because we were willing to sleep almost anywhere. As we set about our camp chores, the last mantling blush of evening sun broke through the heavy sky and illuminated a rather large, obtrusive boulder that lay on top of the hummock behind our tenting ground. Upon examining this several-ton monolith, we realized that we had stumbled upon an ancient waymarker of sorts, or some type of religious site. The rock had been levered up onto three small stones. The colour and type of rock was incongruous with other boulders in the vicinity. The question arose as to how this massive altar had been jimmied into position. The mature trees that might have served as a pry were barely more than sticks and would have snapped easily under such a weight. It was one of those unsolvable mysteries within the Land of Little Sticks.

An elevated waymarker at Tuninili Lake on the Thlewiaza River.

Dechinule is a Dene term meaning "Land of Litte Sticks." It refers to that sub-arctic region where the sky embraces an ever-changing world of glacial debris, sand eskers, endless tracts of taiga parkland, and an intermittent growth of stick-like black spruce. This is the Taiga Shield ecozone, where land and life-forms appear in such a hodge-podge that one is both bewildered and tantalized at the same time. It is represented by a rolling Precambrian plain, almost pastoral in some places, with a thin mantle of glacial deposits atop a scarred and scoured bedrock foundation. Whatever isn't solid rock is permanently frozen terra-firma topped with spongy sphagnum, peat, lichen barrens, boulder trains and morainic sand. Whatever tree manages to grow through this impotent sheath is incidental, almost whimsical.

Running rapids on the Caribou.

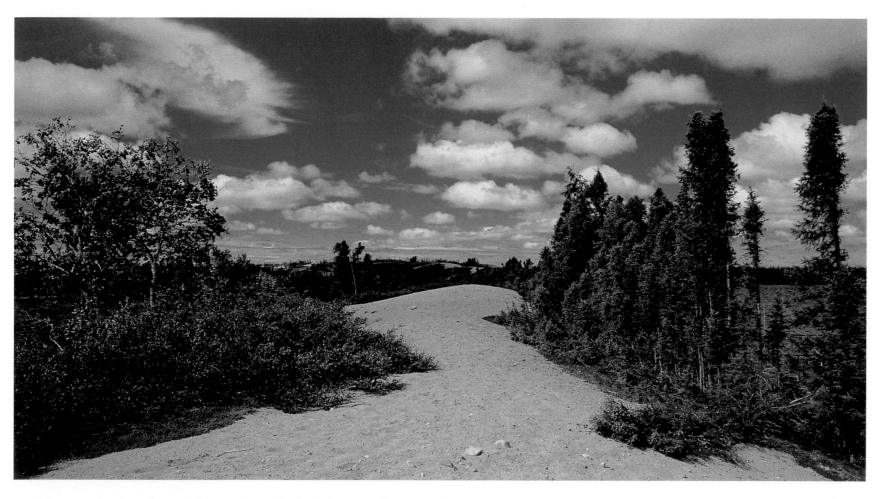

Thousands of caribou trails run through the lichen- and moss-rich barrenlands. This chaotic webwork of pathways depicts the caribou's method of searching for food by following a different route for each passing. Huge herds — albeit reduced from their original magnitude — still devour the tundra lichens, a food source that takes at least thirty years to grow back into edible forage.

In 1939 P. G. Downes, a Boston schoolteacher, made the first recreational canoe trip up the Cochrane River and across the transitional barrenlands to Nueltin, or Sleeping Island Lake. The maps that he used were sketchy, at best, and when he and his partner reached the point of cross-over, the portage from the Cochrane to the Thlewiaza, they

Eskers are the most prominent landscape features through the barren lands. They serve as elevated "highways" for caribou.

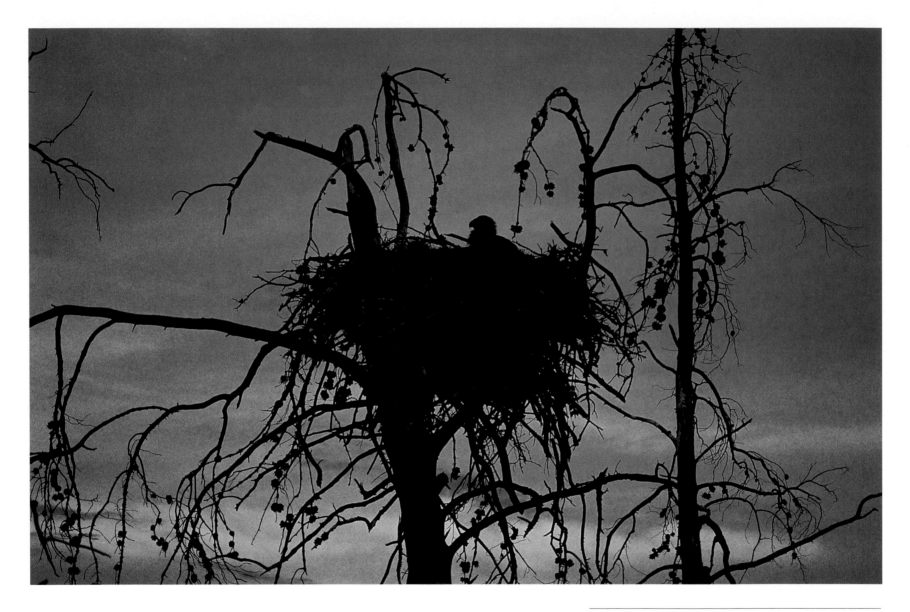

We were fortunate to come across a bald eagle nest only three metres above the esker — but then, few trees grow much higher than that in the Land of Little Sticks.

encountered a different kind of problem. He writes: "The type of country we were in is particularly well adapted to concealing any sort of trail. It is sandy and overgrown with stands of jackpine, very open, there being no underbrush, and carpeted with white caribou or sphagnum moss. Wandering through the mockingly delightful country were literally hundreds of caribou trails, crossing and crisscrossing in every direction. When I started to analyze the problem and set various bits of description and advice one against the other, I became confused and as baffled as if I had tried to follow one of the beguiling game trails."

This is also the land of the Sayisi Dene, "People Under the Sun," known chiefly by the Cree word *Chipewyan*, which means "pointed skins." Their homeland includes most of northern Manitoba and much of Nunavut, now claimed by their traditional enemy, the Inuit. Dene-Nene means the Land of the Dene People, or "the backbone." The constitution of the Dene was as hard as the land they travelled over, their lives aligned closely with the migrations of caribou.

The Dene once depended totally on the movement of caribou for their existence, following eskers as we would highways, usually to hunting sites at water crossings. Today, instead of using bow and arrows and pursuit on foot, the Tadoule Dene charter aircraft to take them to kill sites, where they use all-terrain vehicles to round up the caribou. The animals are quickly slaughtered, gutted and freighted out by plane. Winter hunts are now carried out on snowmachines, replacing snowshoe travel almost completely. Although they have adopted the white man's technology to suit their needs, the Sayisi Dene remain true to the land and have a deep sense of their own culture and place.

The barrenlands is a harsh and austere world where the weather is unpredictable, the wind charges with perpetual fierceness, and lean-mindedness is not tolerated. This marvellous part of Manitoba, along the Seal River, and again traversing the northern

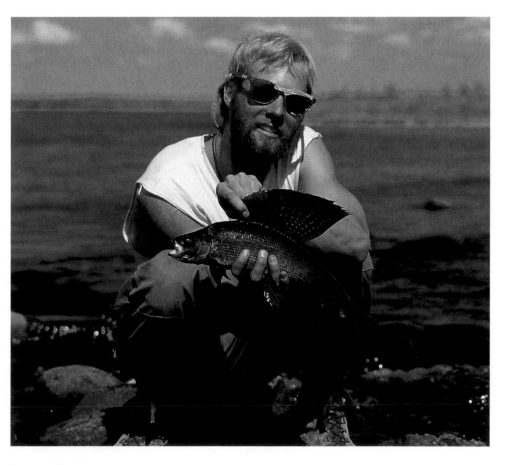

Unprecedented angling exists in the Manitoba wilderness. Here, Walter displays the finned beauty of an arctic grayling.

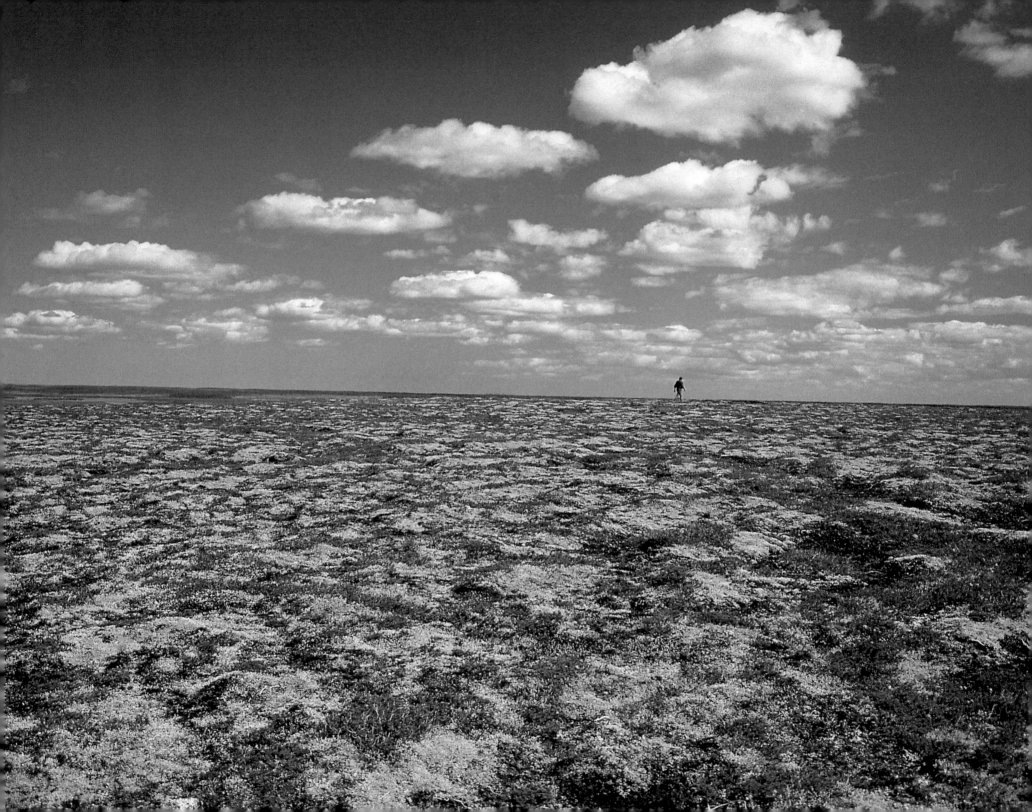

hinterlands from Saskatchewan to Hudson Bay, touched us more deeply than any other place during our journey. Such sentient passion is fostered by a tundra environment and total isolation. As one moves northeast away from the warmth and security of the boreal reaches, the land opens up and lays bare its soul — simple and stoic, yet complex and demure at closer glance. The barrens is a world of opposites, of contradictions, in which the elements have shaped and nurtured a peculiar, seemingly stark and unproductive desert that nonetheless teems with tenacious life-forms and is very much alive in spirit.

A raised peat plateau along the Seal River.

The land swallows you whole, ego and all. Nowhere else in this country will you feel so insignificant yet so much a part of the entire recurring genesis of Nature. Wilderness is a great equalizer, putting us on the same plane as all other species. Here, human bones mingle congenially with those of caribou. This sub-arctic, heath-rich tundra has recorded the history and movements of animals and an ancient people for centuries, in a mosaic of pathways, gravestones, sun-bleached bones, waymarkers and abandoned campgrounds — stories of survival, of death, and of replenishment. The Land of Little Sticks is alluring and addictive. Metaphors betray the full extent of the impression it left upon us.

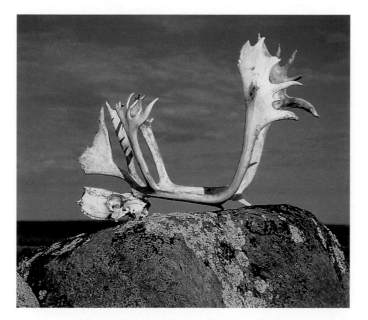

Sun-bleached caribou bones, scattered haphazardly across the tundra constantly reminded us of our own mortality and temporary existence in this great wilderness.

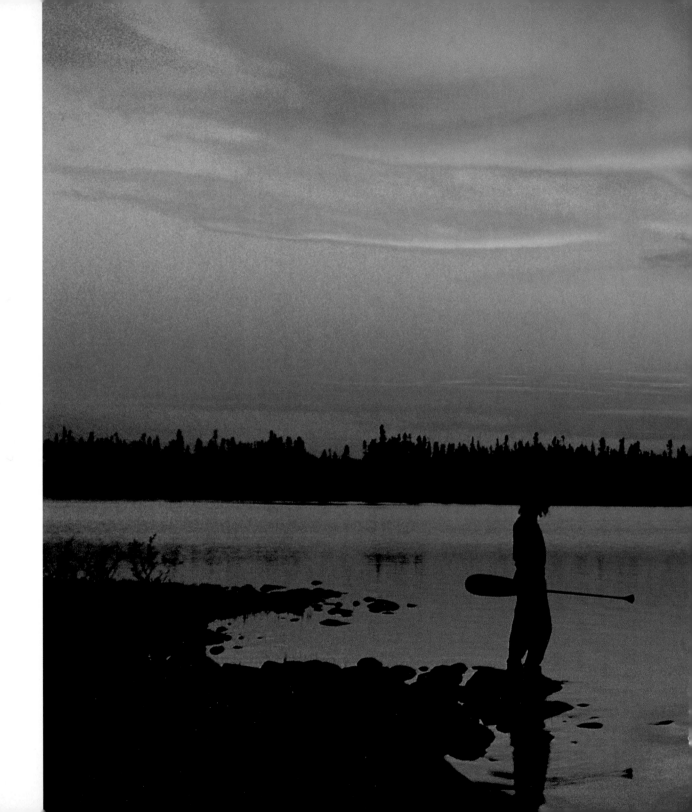

The formation of cirro-stratus clouds indicated that we were in for some foul weather the next day. It also set the scene for a spectacular sunset over the East River on the edge of the barrenlands.

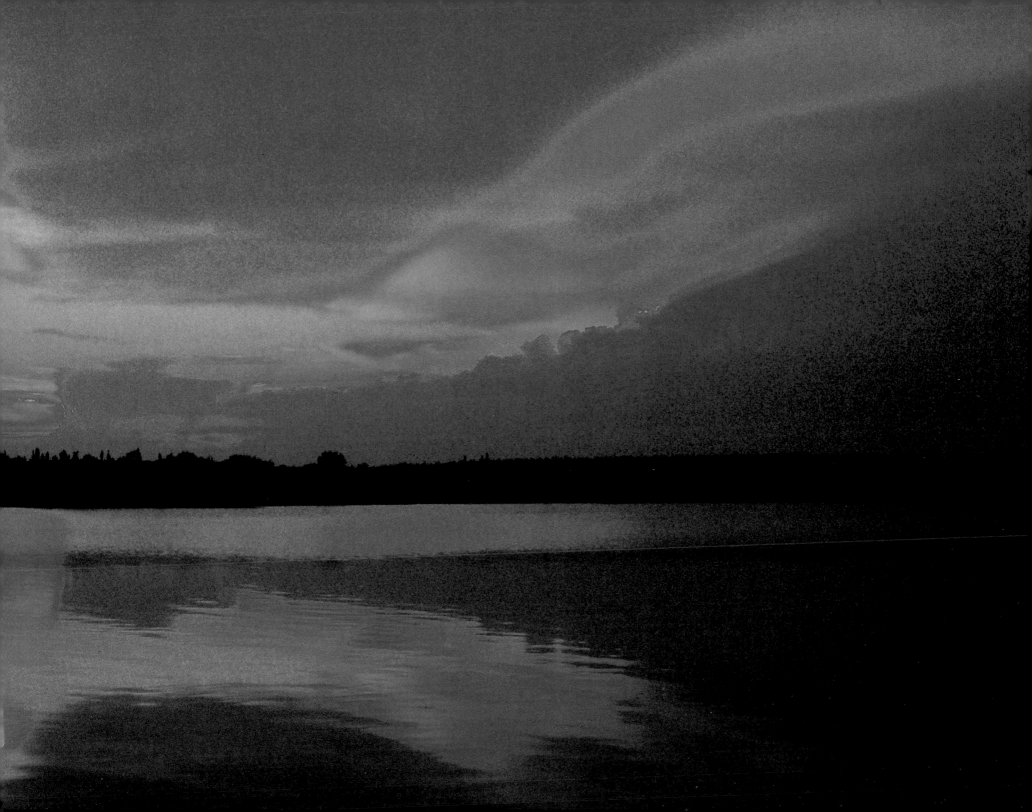

White influence along the remote Caribou River was brief, lasting only a few short years in the 1930s, when the Hudson's Bay Company erected this trading post at Caribou Lake. All that remains is the small church now used by the Sayisi Dene as a shelter while caribou hunting in the winter.

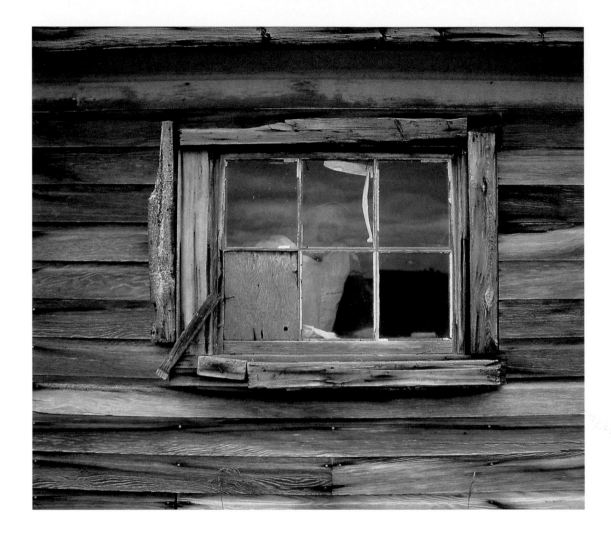

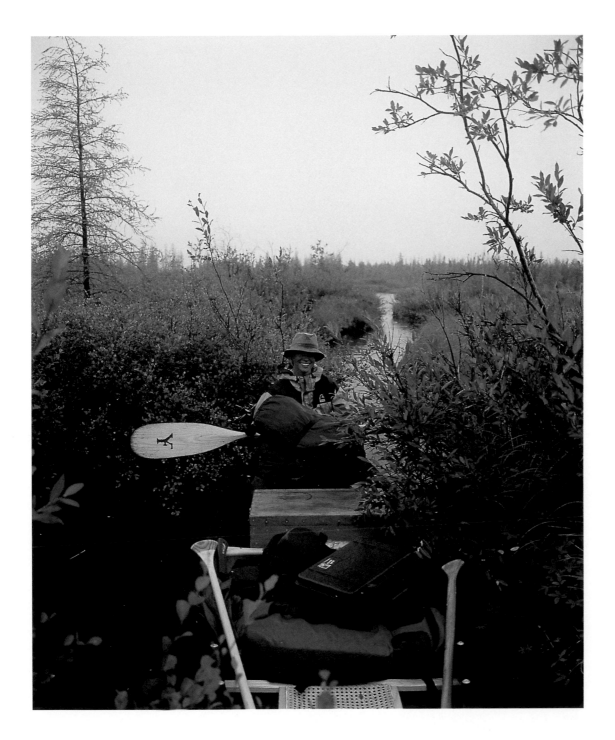

We took a short break following a creek that we hoped would lead us to open water. Finding a route across the barrens was often frustrating. For two weeks there was absolutely no sign of human passage.

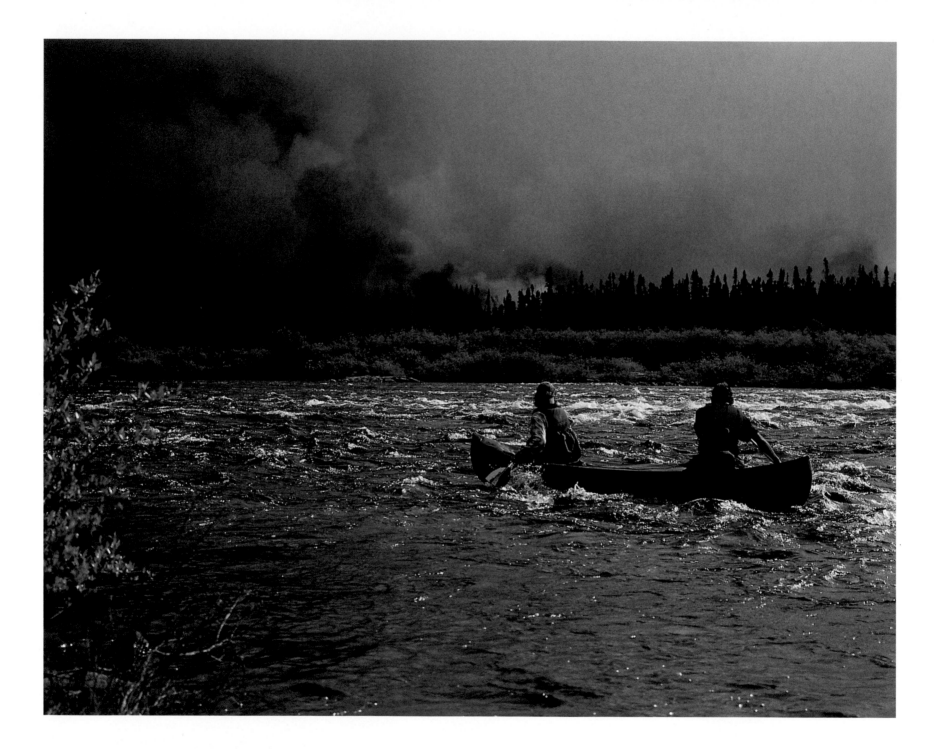

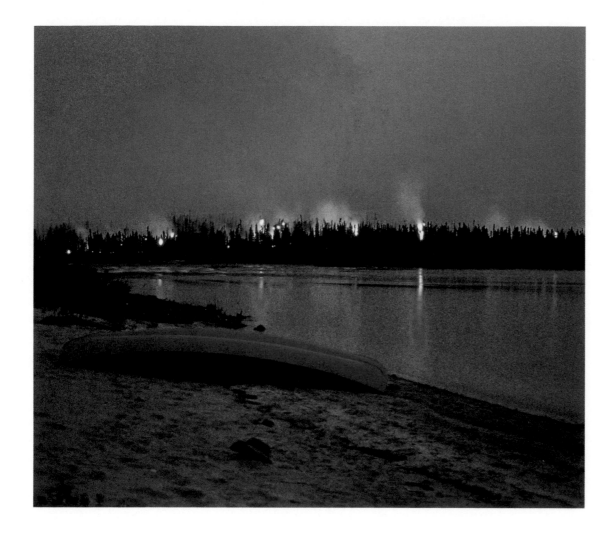

Midnight fires across from our Great Island campsite. There was little respite from the inferno.

We seemed to be paddling directly into the maw of a fiery furnace, the rapids drawing us deeper into the conflagration.

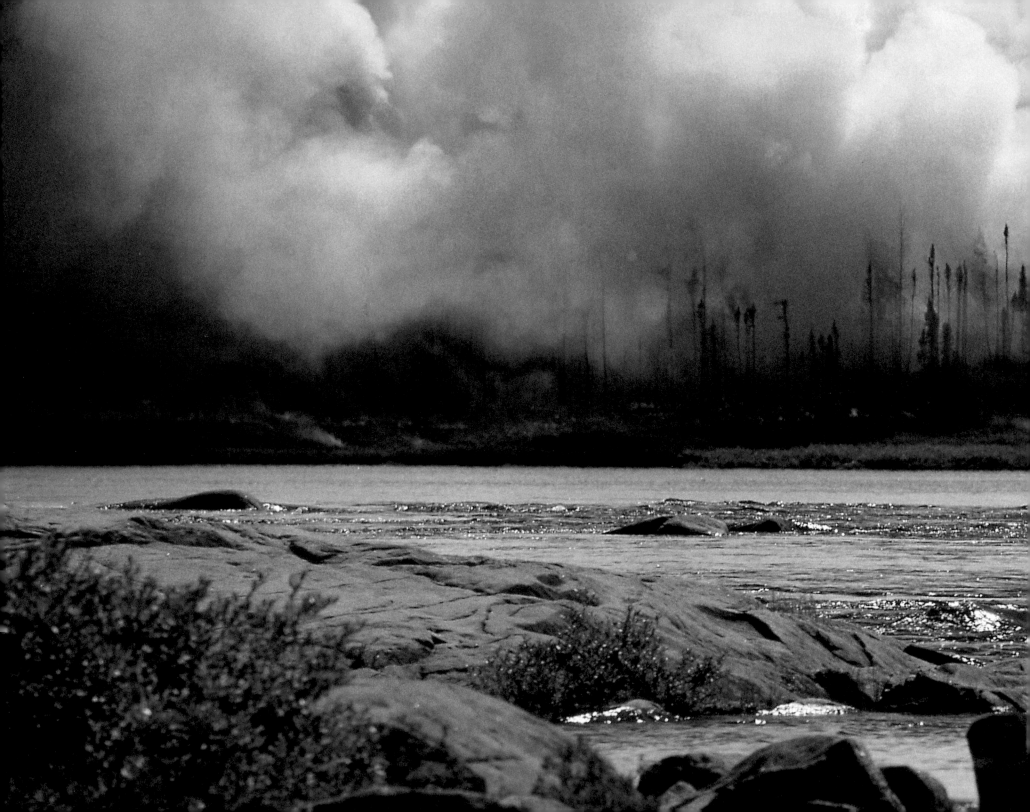

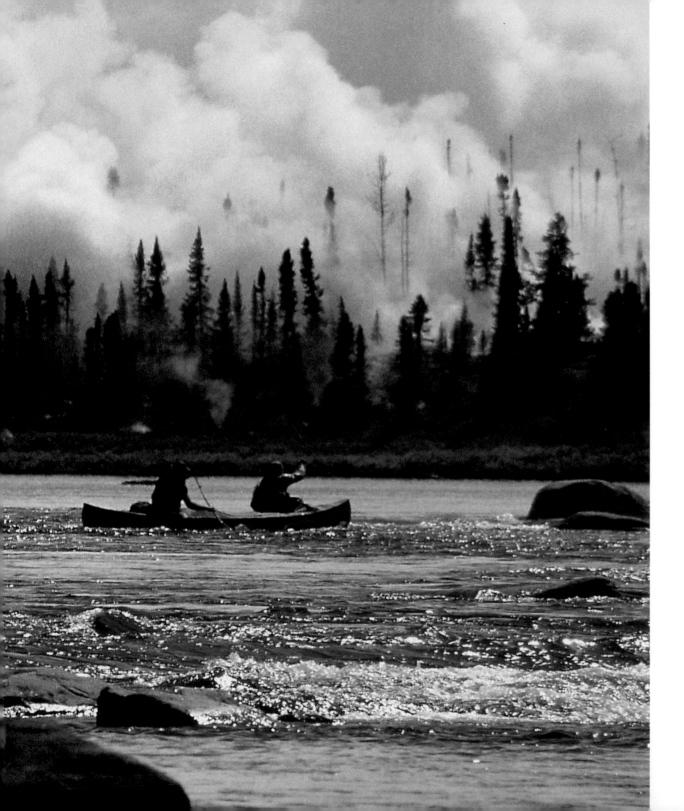

Amidst the "whirlwinds of tempestuous fire," as John Milton writes, we paddled blind, drawn by our own curiosity, awe, and the current of an indifferent river.

We had run out of water on the Roberts River just south of the Nunavut border while making our way to the headwaters of the Caribou River. The only option was to skid our loaded canoes over the tundra's moss and grass. The wind blew incessantly, making it impossible to portage the canoes on our shoulders, and the spongy ground made walking tedious.

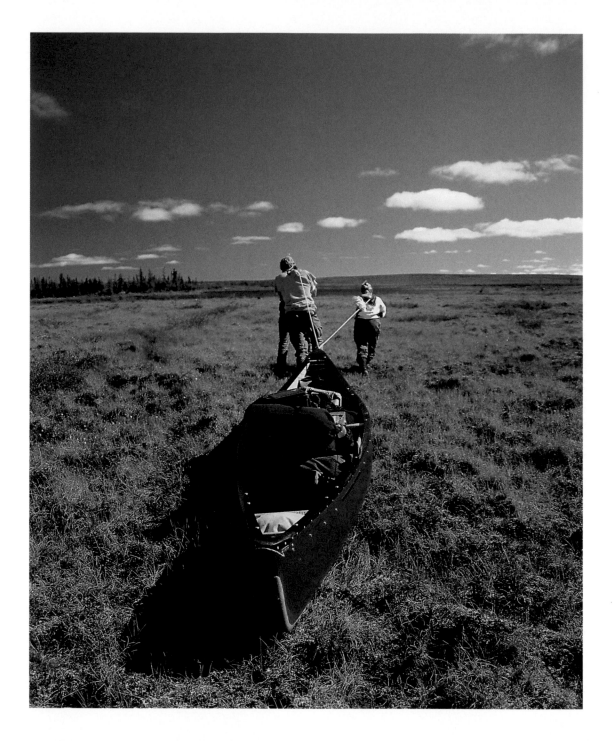

The Caribou River provided us with daily challenges. The weather turned cold and ugly as we neared Hudson Bay, and we were forced to camp for two days in thick sedge along this rocky beach. On the third day the sun shook itself free from its sombre wraps.

This caribou calf can already outrun a tundra wolf. During mosquito season, caribou lose up to a litre of blood a week. By travelling in tight groups, they are able to ward off biting flies by exposing less skin. Over 32,000 caribou fall victim to hunters each year.

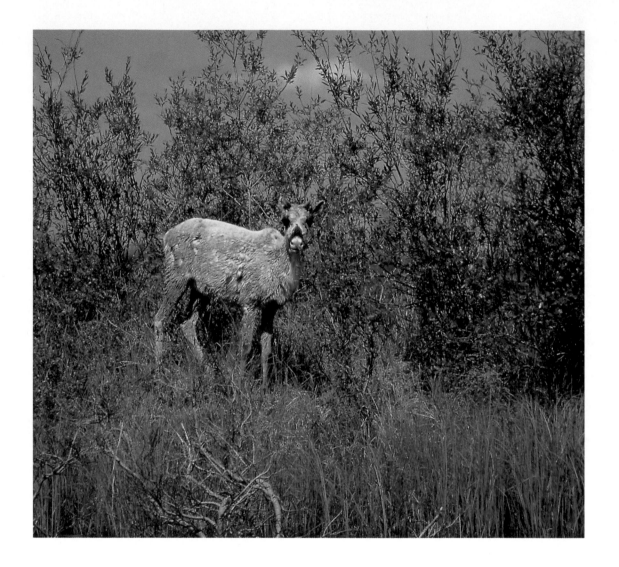

Polar bears are naturally shy and wary, particularly in the short summer months. Nonetheless, having one come within a hundred metres of our shore lunch on the Caribou River quickly reminded us that they were above us on the food chain.

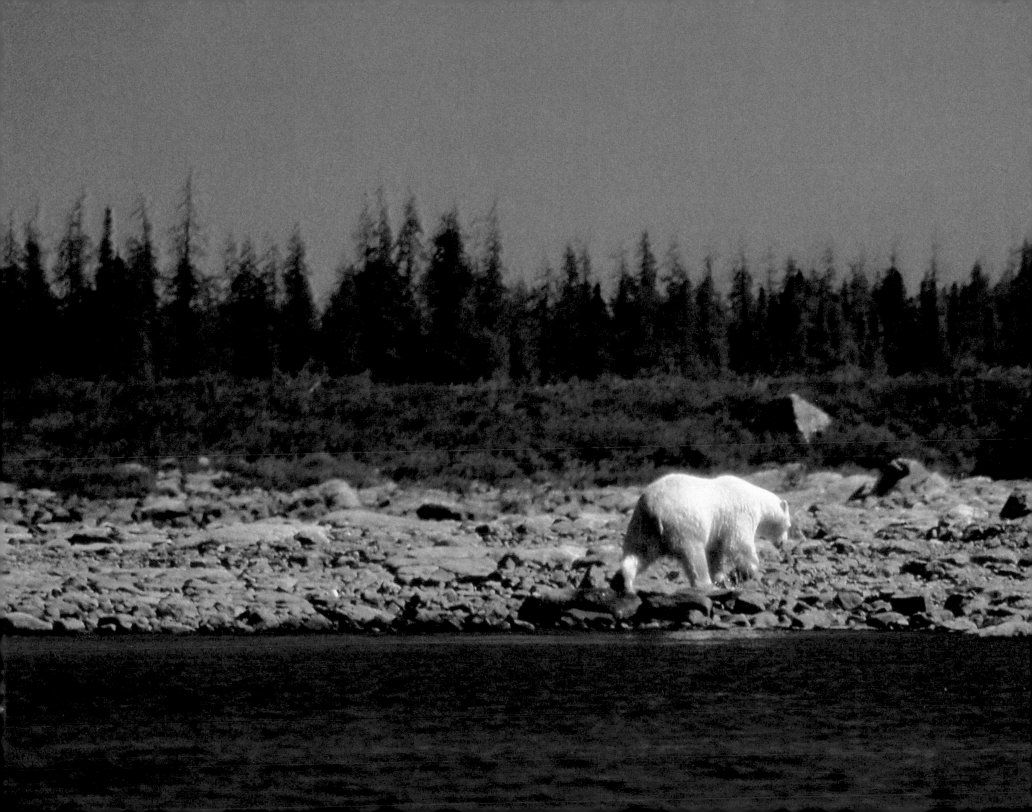

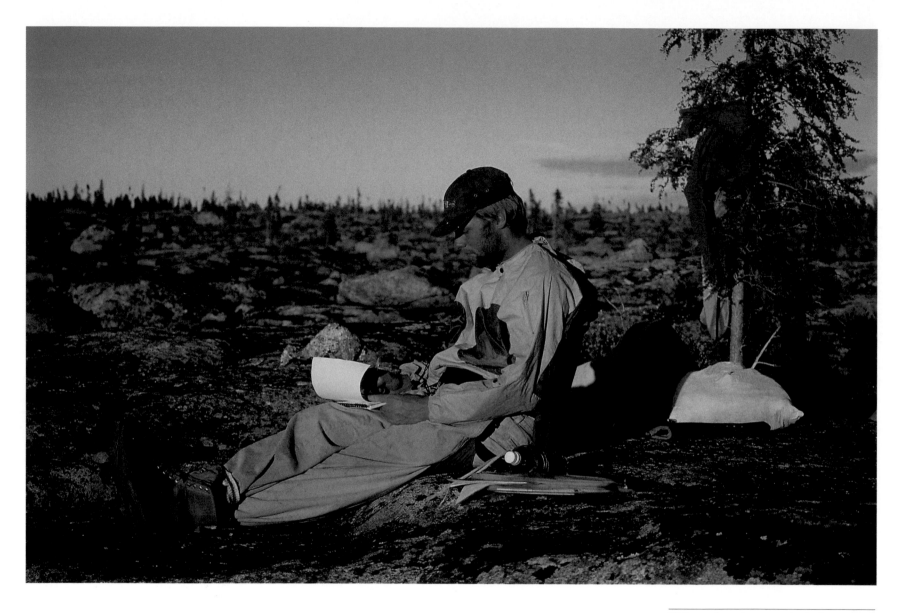

Walter takes time to write in his journal
against a typical tundra landscape.

A smoke-filtered pall enveloped the evening sun and hovered over a scabrous Seal River esker.

Afterword
The Politics of Wilderness

Three years after the Seal River fires, Hap sat on the rocks of an esker on the Caribou River, basking in the same radiant light of sunset — only this time there were no fires, just a natural strangeness to the fiery accents all around.

ITALIAN MATHEMATICIAN AND ASTRONOMER GALILEO GALILEI (1564-1642) DID A LOT OF stargazing. And though he probably never observed the sky from the vantage point of a canoe on a wilderness lake, this man of science had a profound sense of our place in Nature: "It has always seemed to be extreme presumptuousness on the part of those who want to make human ability the measure of what nature can and knows how to do, since, when one comes down to it, there is not one effect in nature, no matter how small, that even the most speculative minds can fully understand." This was quite a spiritual revelation for a man who devoted his life to scientific methodology.

Nature is anything but logical or predictable. (This is probably the reason why we try so hard to improve upon what Nature has taken millions of years to perfect.) Since, to us, the fundamental idea of Nature is spiritual, the application of science in understanding the ways of the natural world is limited. And the current view of Nature and wilderness by public administrators has more to do with lifestyle than science. Wilderness is routinely manipulated to maintain the urban standard of living we have come to expect.

By temporarily sustaining an inflated standard of living, we compromise our quality

Graffiti over Sasaginnigak rock paintings.

of life. We safeguard our creature comforts by unwittingly wholesaling our resources. The quality of our air, our water and our lands are gambled away. Enjoy now, pay later. Though we have travelled Canada's wilderness areas for years and worked for environmental causes, it was not until our son was born that we fully realized the preciousness of the wilderness — for his sake and the sake of each new generation.

But the road to wise use of our dwindling wild places is a rocky one. How can you force a government to be emotional about saving trees or safeguarding rivers? Until we each see wilderness as a spiritual entity necessary for our personal well-being, and not as a commodity, will we not be an enlightened society.

We can only hope that governments will eventually see the forest through the trees and adopt a better understanding of what wilderness means to us all, both economically *and* spiritually.

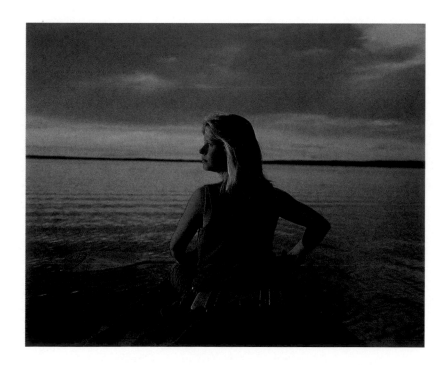

Nejanilini Lake sunset.

Grey Owl Nature Trust
Fiducie de la Nature Grey Owl

THE GREY OWL NATURE TRUST/FIDUCIE DE LA NATURE GREY OWL IS NAMED FOR ONE of Canada's most famous spokespersons for nature and wilderness preservation. Archie Belaney, the Englishman who masqueraded as an Indian under the name Grey Owl, spent a short time in Manitoba in the 1930s. While working for the federal parks, he fought to keep the beaver from extinction through his books, lectures and films, becoming known to many as "Beaver Man."

The Grey Owl Nature Trust is a new charitable foundation created to help citizens in need of critical funding for grassroots environmental efforts. The Trust seeks widespread public assistance in building a multi-million-dollar endowment, the first such public (citizen-based) environmental foundation endowment in Canada. All contributions are tax-deductible. The earned income from this endowment will be granted to charities working to restore and preserve Canada's environment.

All donations to the Trust will be deposited directly into the endowment fund, thereby ensuring that these donations continue to work over the decades to preserve and restore Canada's wealth of wilderness, wildlife, clean water and fisheries. Once endowed, all Canadian charities undertaking environmental projects will be eligible for grants. For further information on how you can help build Canada's first nationwide environmental trust fund, call 1-877-Grey Owl or visit www.greyowltrust.org.

Credits

PHOTOGRAPHY & MAP ART

HAP WILSON: Pages 2, 6-8, 13, 15, 18, 19, 21, 26, 27, 30, 33, 35-37, 39, 40, 42-46, 50-52, 55, 57-60, 65, 67-69, 72, 73, 75, 77-80, 82-83, 85, 86, 88, 89, 92-95, 97, 101, 102, 104, 106, 107, 110-119, 121, 124, 125, 126.

STEPHANIE AYKROYD: Pages 10, 14, 17, 22-24, 28-29, 41, 47-49, 53, 56, 61-63, 66, 70, 71, 76, 81, 84, 87, 90, 91, 96, 99, 100, 103, 105, 108-109, 120, 123.

∽

DESIGN AND LAYOUT BY JOSEPH GISINI
Andrew Smith Graphics Inc., Toronto, Ontario

∽

PRINTED AND BOUND IN CANADA BY FRIESENS
Altona, Manitoba